Contemporary Calligraphy Modern Scribes and Lettering Artists II

Contemporary Calligraphy

Modern Scribes and Lettering Artists II

David R. Godine, Publisher
Boston

This edition published by
David R. Godine, Publisher, Inc.
Horticultural Hall
300 Massachusetts Avenue, Boston 02115

ISBN: 0-87923-877-1
LCC Number: 90 - 84062

First printing
Printed in Portugal

Contents

Introduction

The alphabet is commonplace; using letters and words is routine. But the letters and words illustrated in this book are neither commonplace nor routine. Indeed, every letter, word, sentence and design has been subject to searching and individual thought by calligraphers and lettering artists of international renown. Unlike typesetting, calligraphy and lettering involves consideration of each part of each letter form in relation to its function in the overall design, and they are therefore regarded not only as a craft but as an art form. To quote Paul Standard, the famous American calligrapher; 'Geometry can produce legible letters, but Art alone makes them beautiful. Art begins where geometry ends, imparts to letters a character transcending mere measurement'.

But what of the calligrapher, or scribe, and the lettering artist? A calligrapher works principally with a broad-edged pen or a brush, but the lettering artist, although using pens and brushes too, will also work with different tools, to cut, incise or prepare work for a variety of purposes. Often they are one and the same person, though from time to time the approach and the technique differ because the end result fulfills some different purpose. The calligrapher is often concerned with a unique and individual piece of work, perhaps· working with posterity in mind, and is therefore concerned with the quality and durability of materials as well as excellence of design, technique and presentation. When working for reproduction, however, the piece is often prepared purely for the printer to make his printing plates from and this enables the design to be touched up and corrected. This difference has an important effect on design and concept. The first category may not reproduce so well because the scale, colour, size and visual effect were calculated for first hand viewing. The work for reproduction, however, will be seen in this book as it was originally intended – printed – and may therefore gain an advantage. This needs to be borne in mind when making comparisons. Similar allowances need to be made when looking at inscriptional and three-dimensional work. This book has therefore been divided into three sections: original pieces; work designed for reproduction; and three-dimensional and inscriptional work.

The scribe and lettering artist have a rich and varied array of letter forms to use, with a history of over 4000 years. Today, however, unlike the scribes and letterers of the past, they can work within, or if they choose outside, any tradition. The twentieth century revival of lettering has been described elsewhere and need not be repeated here, but an idea of the historical context is valuable in evaluating the work in this book. All calligraphers will acknowledge a debt, either direct or indirect, to the great teachers and practitioners of calligraphy, lettering and design of the first half of this century, especially in America, Germany and Britain.

Students of such early pioneers as Edward Johnston, Eric Gill, Rudolf Koch and Ernst Detterer are still working today, and by this we can realise how brief the modern revival of calligraphy has been. Nor has its development been steady and untroubled. Sheila Waters writing in *Lettering Today* published in 1964, said in her perceptive introduction, 'During the last few years a situation has been developing which seriously threatens the future of calligraphy in this country.' She pointed out that calligraphy was being dropped as a subject at art schools and 'no longer seems

to be regarded as having any value within [graphic design] courses of training.' She further pointed out that the antipathy between typographic designers and calligraphers resulted from mutually held misconceptions, a state of affairs which did not exist abroad where calligraphy was more valued and more widely used. She further commented, by way of explanation, that much calligraphy being produced had a dated, pre-war flavour 'using the same formula, untouched by any developments of style and arrangement'. This, compared with the rapid strides being made in graphic design, left calligraphic work alienated. A contributory factor was the way in which calligraphy had sometimes been taught, isolated from other art departments, unrealistic and unrelated to graphic design generally. 'Experiments have always been made in past centuries, and must continue to be made if the craft is to live. The possibilities of calligraphy as a form of personal expression have hardly been explored . . . Young designers should not be ignorant of the origins of the alphabet, of the development of our language and its visual means of expression . . . New processes of reproduction are making an endless variety of type design possible, and the scope for hand lettering will be limitless. How vital it is then that those who design for these new processes, and produce lettering which affects everyone in daily life should begin by receiving a sound basic training in good lettering so that they design from knowledge and do not go astray through ignorance.' Sheila Waters was writing in the mid-sixties but it was not until nearly a decade later that any developments can be discerned. The situation in art colleges is still not much better, though there are signs of a growing

awareness of the importance of calligraphy, but there is a great deal more interest among adults in calligraphy as a pastime in the United States, Britain, and indeed throughout the world. It is in America, however, that the most significant developments have come about, where the barriers between graphic designers and calligraphers are less evident and, increasingly, are breaking down altogether. During the last decade American calligraphy has developed along an increasingly independent path, encouraged by imaginative and enthusiastic teaching and an open-minded attitude which encourages experimentation. With inspiring British teachers, such as Donald Jackson and Sheila Waters, supplying a strong element of craftsmanship; Germans such as Hermann Zapf a strong tradition of type design allied to calligraphy; and American teachers, such as Thomas Ingmire, advocating more personal expression, the potency and vitality of American calligraphy is now having an increasing influence worldwide.

As can be seen, a large majority of the contributors to this book come from Britain or the United States; and the most significant development in calligraphic terms, which has come about in these countries, is the way in which calligraphy and lettering is being used as a means of personal expression and as an interpretative medium. It is this newly explored aspect which is truly a twentieth-century development and which has attracted the imagination of many thousands of amateurs as well as the connoisseur and collector. Where the choice of text is allied to consumate skill in presentation, then lettering becomes an art form with an extra – literary – dimension.

The inscriptional work shown here is almost

Facing page
Sam Somerville
Written with metal pens and quills on a slunk calfskin vellum panel in
watercolour with burnished gold, gum ammoniac/PVA and powder gold
gilding. After writing the vellum has been stretched over a rigid support
whose surface has been coloured to utilise the translucency of the vellum.
26×42.5 cm ($10\frac{1}{4} \times 16\frac{3}{4}$ in)

exclusively from Britain, with a few submissions from
Germany and America. There is a small but increasing
number of people in the United States producing
incised work of quality in stone, following the
influences of Catich and John Howard Benson. In
Germany there is, in certain areas, a strong almost
sculptural approach to memorial design with
inscriptions often being laid out directly with a broad-
edged brush. This more sculptural approach, often
using varied forms and textured surfaces, is an
interesting contrast to the primarily graphic 'linear-
incised' approach of British letter cutters. Of the
inscriptional material most is incised in stone, though
there are notable contributions cut in other materials
such as brick or fine woods. Letter cutting in wood is
an under-used aspect of lettering which holds many
creative possibilities for the sensitive cutter. As will be
seen from the examples chosen, even what may seem
unpromising can, in the hands of a creative and witty
designer, become entertaining. To see an
imaginatively designed doorway or house name in a
street full of plastic fascias and 'hamburger lettering' is
like a good deed in a wicked world. The craft of the
letter cutter has been much under-rated, but the
examples shown here give rise to optimism. The work
represented is some of the finest to be seen and shows
that the traditions nurtured by Eric Gill are still being
sustained by such craftsmen as John Skelton and David
Kindersley and many others.

There is much scope for lettering in such materials
as glass and plastics, but the full potential of these
media has yet to be explored.

Overall, the selection of work in this book
represents the calligraphy and lettering of 124 scribes
and letterers from 12 countries. Nearly all the
examples have been done during the last four years and
represent works on paper, vellum, fabric, slate, stone
and glass and done with brush, pen, and chisel. They
range from one-off pieces to ephemera, greeting cards,
signage, memorial inscriptions, panels and books. A
veritable feast of contemporary lettering art.

In conclusion, perhaps the words of Hermann Zapf
in his *The Calligrapher in our time – a Manifesto. For the
Society of Scribes and Illuminators – 1983* can speak for
the scribe and lettering artist: 'We don't create heroic
things to earn fame, nor do we put scratches on the
globe, but perhaps with our gentle art we do add a few
little dabs of joy into life, writing with the complete
engagement of our heart . . . No calligrapher can
pollute rivers with his ink, or poison the air which we
breathe. Calligraphy makes no noise. We don't fight
with arms or with our pens, but sometimes we do
want to convince with a handwritten message of
special importance in which we believe. Of course, we
know we are not the centre of the world, we merely
like to make nice things with our given talent. And we
have a burden of responsibility, the heritage of the
great masters of the past, the tradition of the scribes of
the Middle Ages, of the royal and imperial ancestors
in Europe and Asia. Calligraphy is still a royal
activity . . .'

Peter Halliday
January 1986

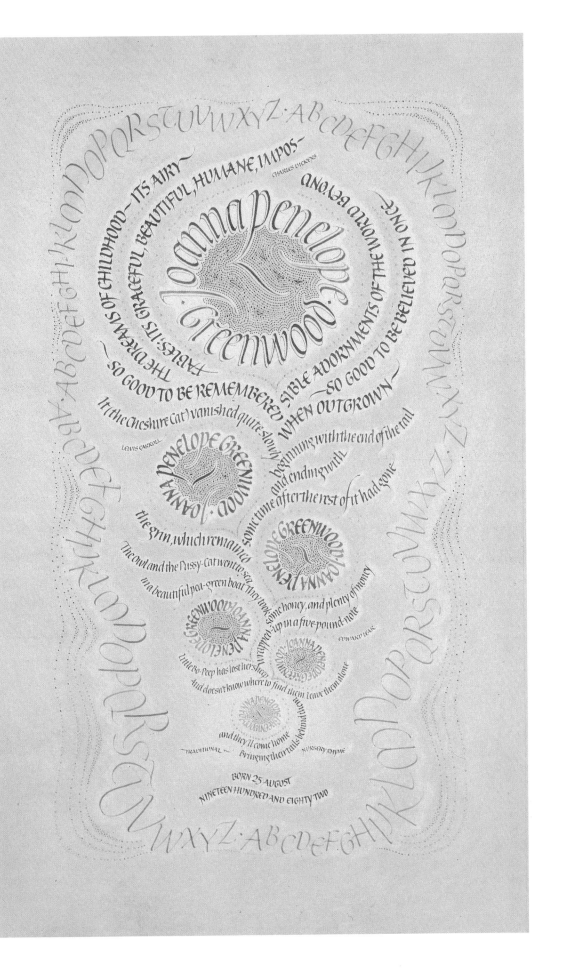

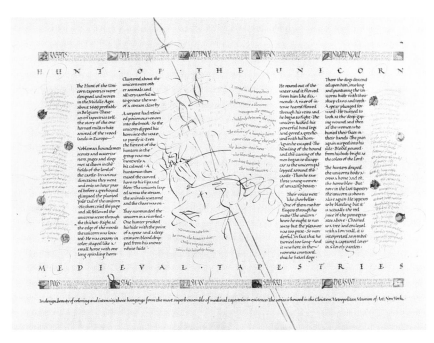

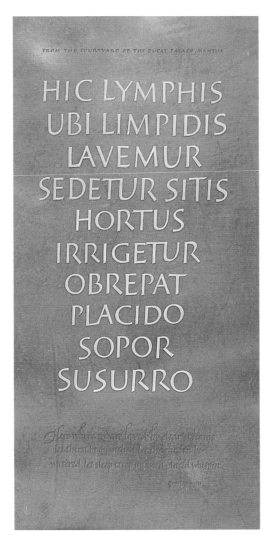

Georgia Deaver
'The Hunt of the Unicorn'. Design based on a tapestry. Written with quills in watercolour, pastel, shell, ammoniac and gesso gold on vellum.

Dorothy Mahoney
'Town House'. From *Painting for Calligraphers* by Marie Angel. Vellum panel, pen, watercolour washes and vermilion and gilding. Reproduced by permission of Pelham Books. 44.5 × 15.9 cm ($17\frac{1}{2} × 6\frac{1}{4}$ in)

Gerald Fleuss
'Hic Lymphis'. Inscription from the courtyard of the Ducal Palace, Mantua. Brush and pen lettering in grey with the English translation in scarlet gouache on charcoal dyed vellum. Commissioned by Michael Taylor. Reproduced by courtesy of the Houghton Library, Harvard University. 44.3 × 22.2 cm ($17\frac{1}{2} × 8\frac{3}{4}$ in)

Donald Jackson
Burnished gold and gesso base with leaf also burnished into the surface of the sized Fabriano paper. The pale letters are ungilded gesso written with a quill.
12.7 × 112.7 cm (5 × 5 in)

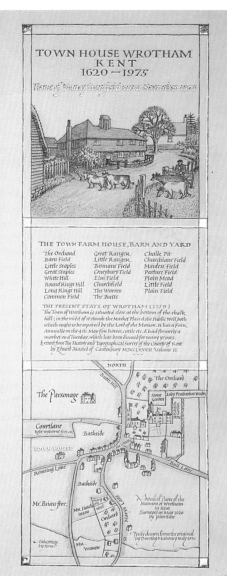

Stan Knight
'In lovely harmony'. Welsh verse
by Thomas Telynog Evans (1840–
1865). One of four panels
representing the seasons. Written
and painted on Arches aquarelle
paper in watercolour with
occasional use of masking fluid.
40 × 26 cm ($15\frac{3}{4}$ × $10\frac{1}{4}$ in)

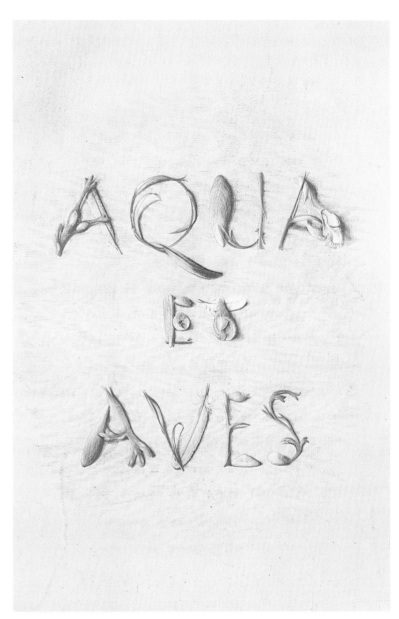

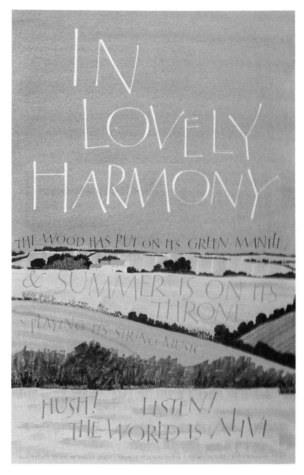

Marie Angel
'Aqua et Aves' from *Painting for
Calligraphers* by Marie Angel.
Watercolours on vellum.
Reproduced by permission of
Pelham Books. 25.4 × 18.4 cm
(10 × $7\frac{1}{4}$ in)

David Wood
English Street Ballad. Written with
steel nibs, brush and gouache on
Arches paper.

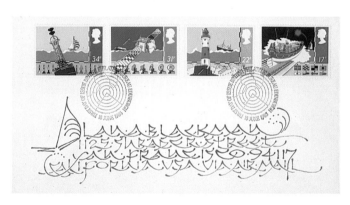

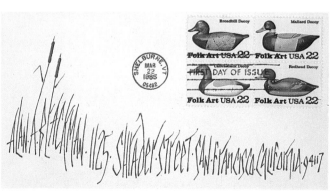

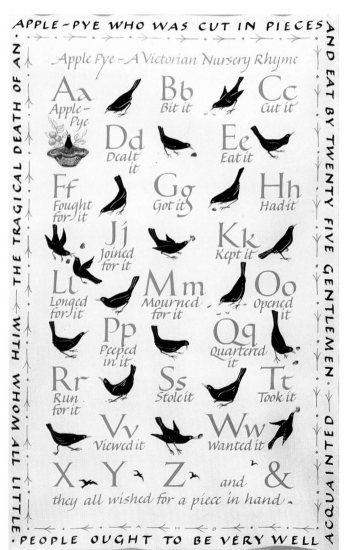

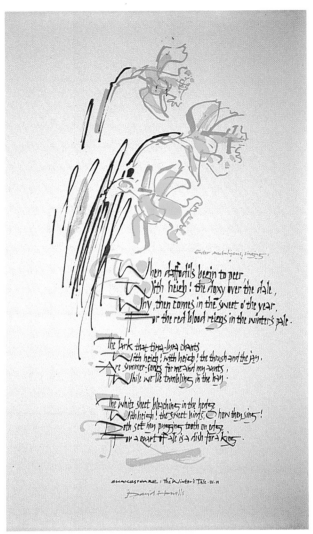

Enter Autolycus, singing:

When daffodils begin to peer,
With heigh! the doxy over the dale,
Why, then comes in the sweet o' the year,
For the red blood reigns in the winter's pale.

The lark that tira-lyra chants
With heigh! with heigh! the thrush and the jay,
Are summer-songs for me and my aunts,
While we lie tumbling in the hay.

The white sheet bleaching on the hedge
With heigh! the sweet birds, O how they sing!
Doth set my pugging tooth on edge,
For a quart of ale is a dish for a king.

Shakespeare : The Winter's Tale · IV · III

David Howells

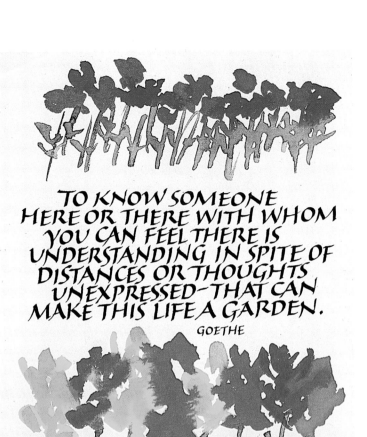

TO KNOW SOMEONE
HERE OR THERE WITH WHOM
YOU CAN FEEL THERE IS
UNDERSTANDING IN SPITE OF
DISTANCES OR THOUGHTS
UNEXPRESSED – THAT CAN
MAKE THIS LIFE A GARDEN.

GOETHE

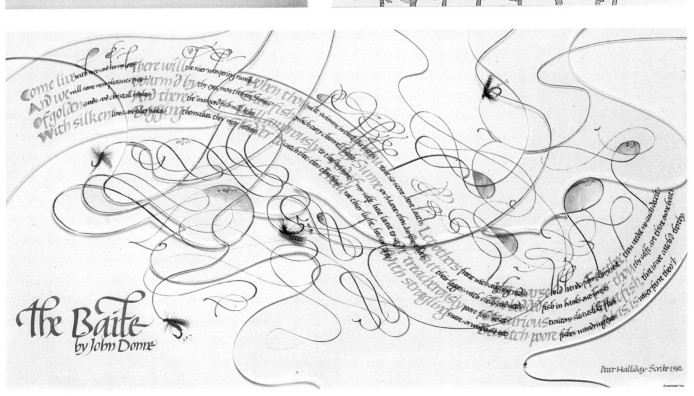

The Baite
by John Donne

Peter Halliday-Scribe 1982

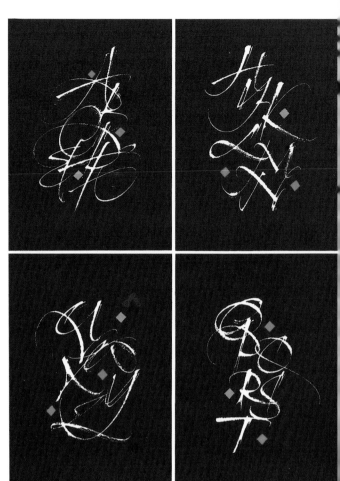

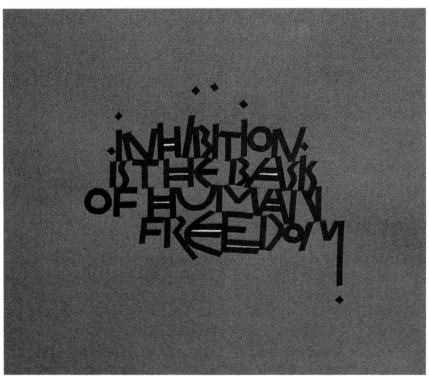

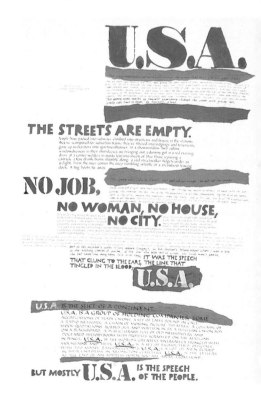

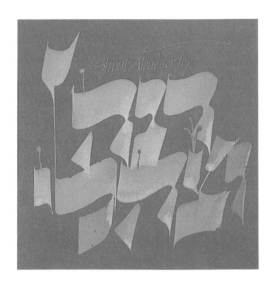

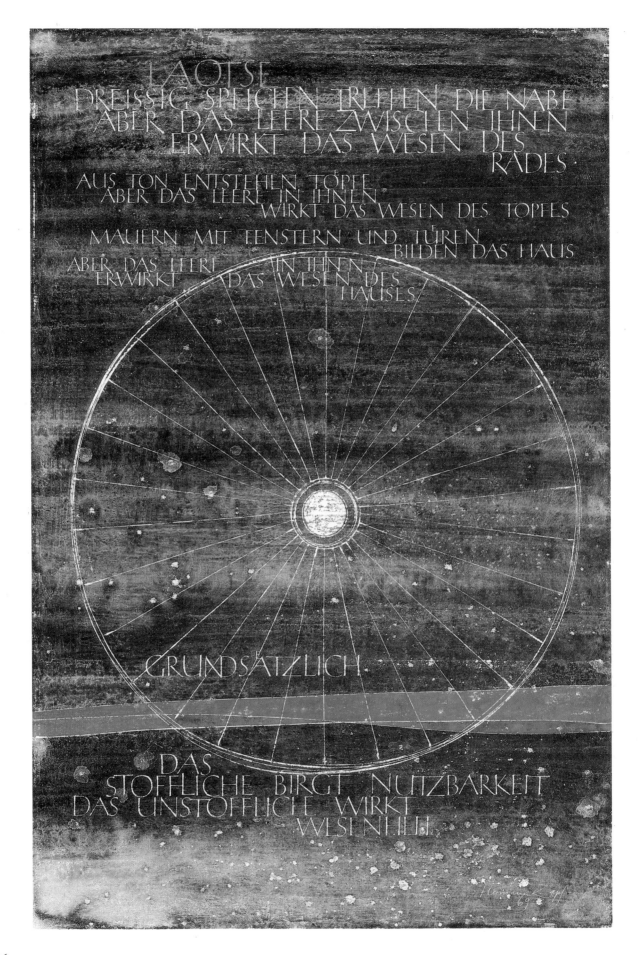

LAOTSE
DREISSIG SPEICHEN TREFFEN DIE NABE
ABER DAS LEERE ZWISCHEN IHNEN
ERWIRKT DAS WESEN DES
RADES.

AUS TON ENTSTEHEN TÖPFE
ABER DAS LEERE IN IHNEN
WIRKT DAS WESEN DES TOPFES

MAUERN MIT FENSTERN UND TÜREN
BILDEN DAS HAUS
ABER DAS LEERE IN IHNEN
ERWIRKT DAS WESEN DES
HAUSES.

GRUNDSÄTZLICH

DAS
STOFFLICHE BIRGT NUTZBARKEIT
DAS UNSTOFFLICHE WIRKT
WESENHEIT.

16

Calligraphy and lettering

Derrick Pao
'Alphascape'. Embossed on handmade paper. 28.5 × 21 cm (11¼ × ¼ in)

'ABC'. Embossed on handmade paper. 21.5 × 15.5 cm (8½ × 6⅛ in)

'Z'. Embossed on handmade paper. 19 × 18 cm (7½ × 7 in)

Facing page, left
Marsha Brady
'Letter to a friend'. Written in gouache with Brause nibs on light grey Fabriano Roma paper. 25.4 × 66 cm (10 × 26 in)

Facing page, right
Donald Jackson
Initials 'TS'. Beginning of a letter to Toko Shinoda. Width of initials 10 cm (4 in)

I SALUTE YOU

I AM YOUR FRIEND AND MY LOVE FOR YOU GOES DEEP. THERE IS NOTHING I CAN GIVE YOU WHICH YOU HAVE NOT GOT: BUT THERE IS MUCH, VERY MUCH THAT, WHILE I CANNOT GIVE IT, YOU CAN TAKE. NO HEAVEN CAN COME TO US UNLESS OUR HEARTS FIND REST IN TODAY. TAKE HEAVEN! NO PEACE LIES IN THE FUTURE WHICH IS NOT HIDDEN IN THIS PRESENT LITTLE INSTANCE. TAKE PEACE! THE GLOOM OF THE WORLD IS BUT A SHADOW. BEHIND IT, YET WITHIN OUR REACH, IS JOY. THERE IS RADIANCE AND GLORY IN THE DARKNESS, COULD WE BUT SEE – AND TO SEE WE HAVE ONLY TO LOOK. I BESEECH YOU TO LOOK. LIFE IS SO GENEROUS A GIVER, BUT WE, JUDGING ITS GIFTS BY THEIR COVERING, CAST THEM AWAY AS UGLY, OR HEAVY OR HARD. REMOVE THE COVERING AND YOU WILL FIND BENEATH IT A LIVING SPLENDOR, WOVEN OF LOVE, BY WISDOM, WITH POWER. WELCOME IT, GRASP IT, AND YOU TOUCH THE ANGEL'S HAND THAT BRINGS IT TO YOU. EVERYTHING WE CALL A TRIAL OR A SORROW OR A DUTY, BELIEVE ME, THAT ANGEL'S HAND IS THERE, AND THE WONDER OF AN OVERSHADOWING PRESENCE. OUR JOYS TOO: BE NOT CONTENT WITH THEM AS JOYS. THEY TOO CONCEAL DIVINER GIFTS. LIFE IS SO FULL OF MEANING AND PURPOSE, SO FULL OF BEAUTY – BENEATH ITS COVERING – THAT YOU WILL FIND EARTH BUT CLOAKS YOUR HEAVEN. COURAGE THEN TO CLAIM IT, THAT IS ALL! BUT COURAGE YOU HAVE; AND THE KNOWLEDGE THAT WE ARE PILGRIMS TOGETHER, WENDING THROUGH UNKNOWN COUNTRY, HOME. AND SO I GREET YOU. NOT QUITE AS THE WORLD SENDS GREETINGS, BUT WITH PROFOUND ESTEEM AND WITH THE PRAYER THAT FOR YOU, NOW AND FOREVER THE DAY BREAKS AND THE SHADOWS FLEE AWAY. *Fra Giovanni*

LETTER TO A FRIEND

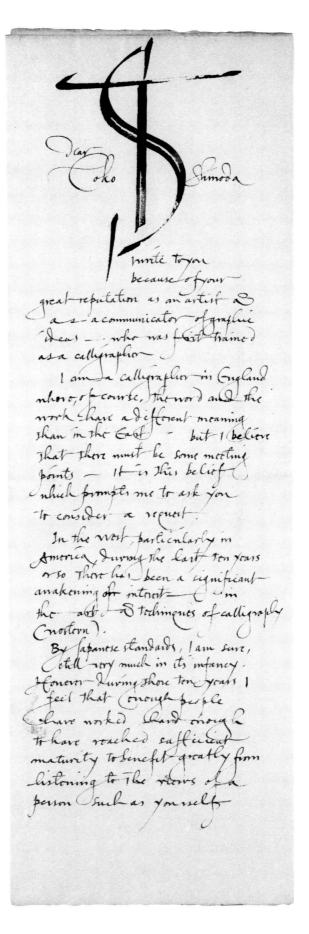

Dear Toko Shimoda

I write to you because of your great reputation as an artist & a – a communicator of graphic ideas – who was first trained as a calligrapher.

I am a calligrapher in England where, of course, the word and the work have a different meaning than in the East – but I believe that there must be some meeting points – it is this belief which prompts me to ask you to consider a request.

In the West, particularly in America, during the last ten years or so there has been a significant awakening of interest – in the art & techniques of calligraphy (western).

By Japanese standards, I am sure, it is very much in its infancy. However – during those ten years I feel that enough people have worked hard enough to have reached sufficient maturity to benefit greatly from listening to the views of a person such as yourself.

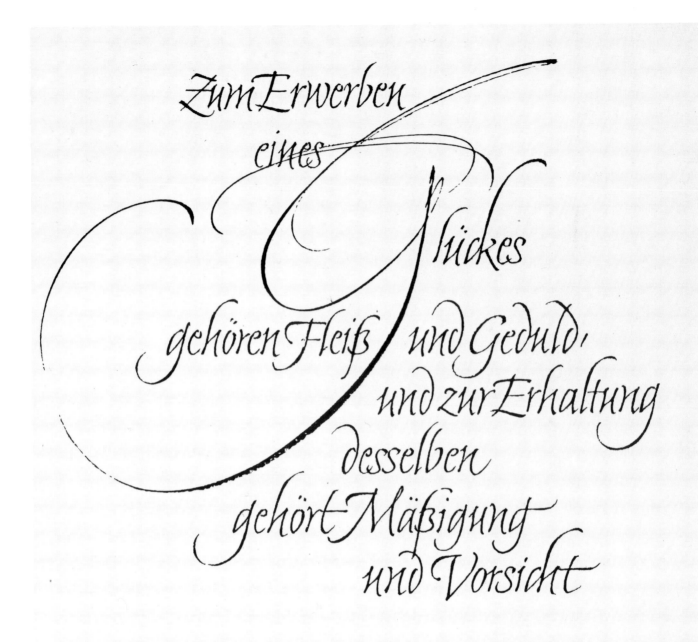

*Zum Erwerben
eines
Glückes
gehören Fleiß und Geduld,
und zur Erhaltung
desselben
gehört Mäßigung
und Vorsicht*

Johann Peter Hebel

Alfred Linz
Quotation from Johann Peter
Hebel. Watercolour on
watercolour paper. Width of
lettering 17 cm (6¾ in)

Donald Jackson
One of nine panels 1 metre (39½ in)
high using brilliant gouache and
dyes over a masking-fluid resist
applied with a quill. Written in
four languages with a reed pen and
stick ink. For an exhibition of
photographs recording the work of
the International Council on
Monuments and Sites, Paris.

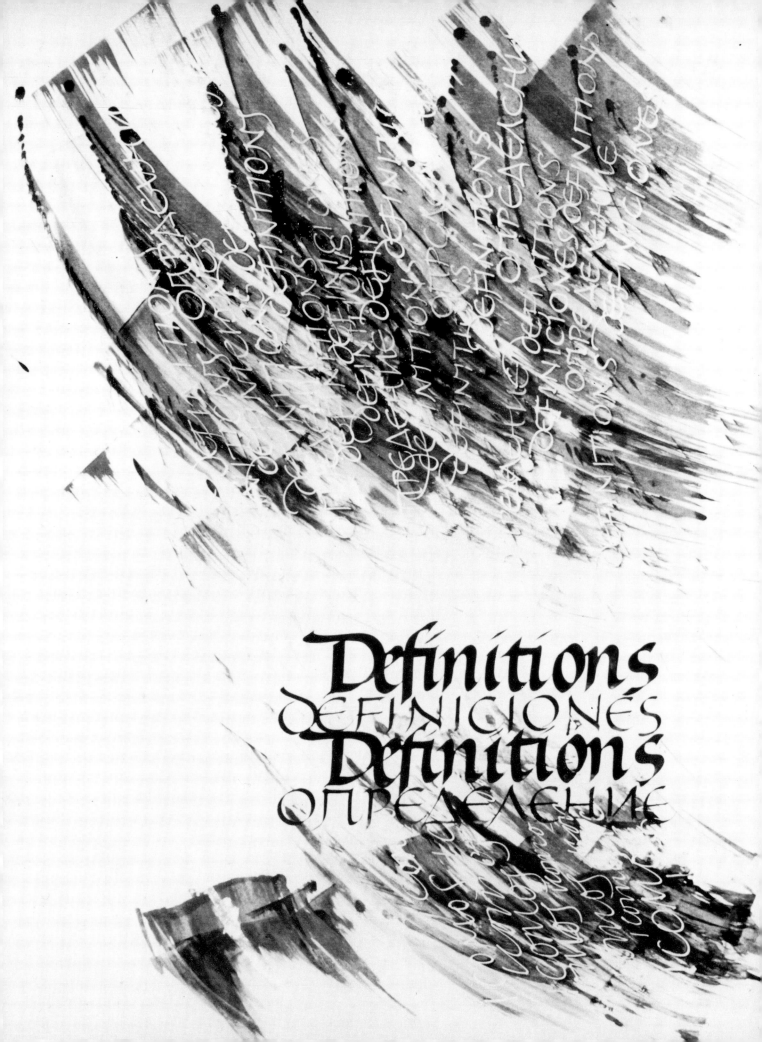

Definitions
DEFINICIONES
Definitions
ОПРЕДЕЛЕНИЕ

Margaret Prasthofer
'I loved her like the leaves'. Quotation from the ninth century Japanese poet Kakinomato Hitomaro. Written in black ink, with vermilion, gilding and hand-ground pigments on Swedish paper. 53.3 × 78.7 cm (21 × 31 in)

Facing page, top left
Michael Harvey
Homage to Duke Ellington. The letters were stencilled in acrylic paint, the black lettering drawn with a pointed pen on Canson paper. 74.9 × 55.1 cm (29½ × 21¾ in)

Facing page, bottom left
Alfred Linz
Quotation from George Herbert. Written out in watercolour on white paper for the Hermann-Foster-Verlag. 8.5 × 11.1 cm (3⅜ × 4⅜ in)

Facing page, right
Margaret Prasthofer
William Morris's 'Tulip and Willow', with a quotation from his essay 'The Lesser Arts'. Vellum with hand-ground pigments. 29.2 × 63.5 cm (11½ × 25 in)

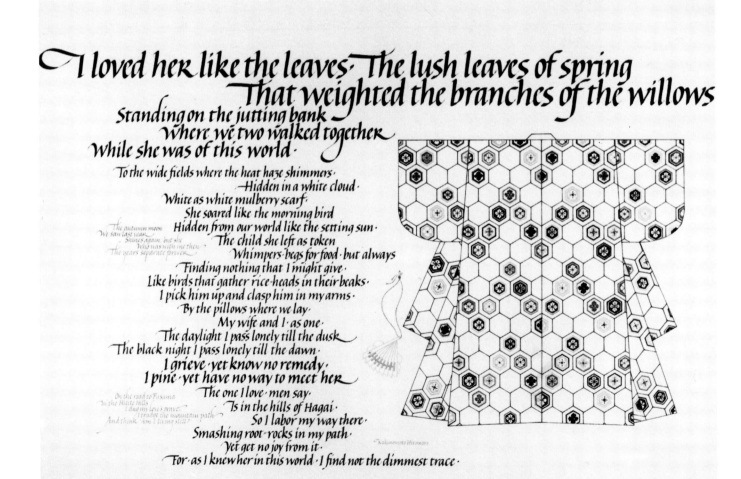

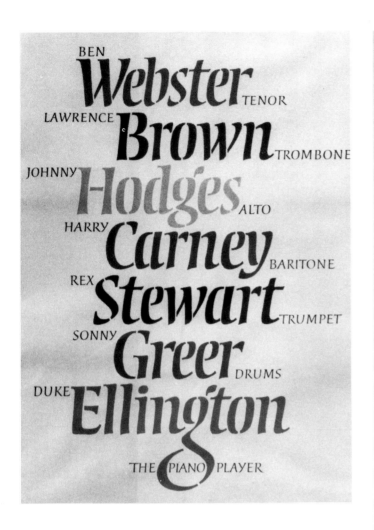

BEN **Webster** TENOR
LAWRENCE **Brown** TROMBONE
JOHNNY **Hodges** ALTO
HARRY **Carney** BARITONE
REX **Stewart** TRUMPET
SONNY **Greer** DRUMS
DUKE **Ellington**

THE PIANO PLAYER

Liebe und Husten lassen sich nicht verbergen. *George Herbert*

Now it is one of the chief
uses of decoration,
the chief part of its alliance
with nature, that
it has to sharpen our dulled
senses in this matter:

Tulip & Willow

for this end are those
wonders of intricate patterns
interwoven, those strange
forms invented, which men
have so long delighted in:
forms and intricacies
that do not necessarily imi
tate nature, but in
which the hand of the
craftsman is guided to work
in the way that she does,
till the web, the cup,
or the knife, look as natural,
nay, as lovely, as
the green field, the river bank,
or the mountain flint.

WILLIAM MORRIS – THE LESSER ARTS
MARGARET PRASTHOFER 83

23

Lilly Lee
Experimental alphabet. Brush lettering and gouache. Detail. Text of Japanese Haiku. Height of letters 6.1 cm (2½ in)

Margaret Prasthofer
Pueblo Indian quotation on fabric. Written in felt pens. 73.7 × 78.7 cm (29 × 31 in)

Facing page
Gerald Fleuss
'Ecce magi ab oriente', Matthew ii I,2. Pen lettering in purple and white, with shell gold, raised and burnished gold on blue-dyed vellum. In the Victoria & Albert Museum Collection. Commissioned by Michael Taylor. 30.5 × 20.3 cm (12 × 8¾ in)

ECCE

BEHOLD

MAGI AB ORIENTE

THERE CAME WISE MEN

venerunt Jerosolymam

FROM THE EAST TO JERUSALEM

Dicentes, ubi est qui

SAYING WHERE IS THE

natus est Rex Judæorum?

KING OF THE JEWS THAT IS BORN?

vidimus enim stellam

FOR WE HAVE SEEN HIS STAR

ejus in oriente, et

IN THE EAST AND WE ARE

venimus adorare eum

COME TO WORSHIP HIM

Matthew ii 1 & 2

LATIN VULGATE

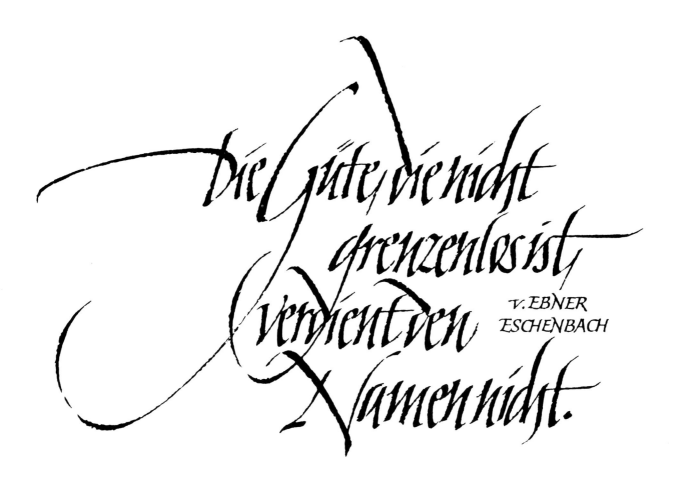

Alfred Linz
Quotation from V. Ebner Eschenbach. Watercolour on handmade paper. 18 × 12 cm (7⅛ × 4¾ in)

Brody Neuenschwander
'A Coney Island Life'. Poem by James Weil. Written with orange and brown watercolours on Ingres Fabriano cream laid paper. 24.8 × 91.4 cm (9¾ × 36 in)

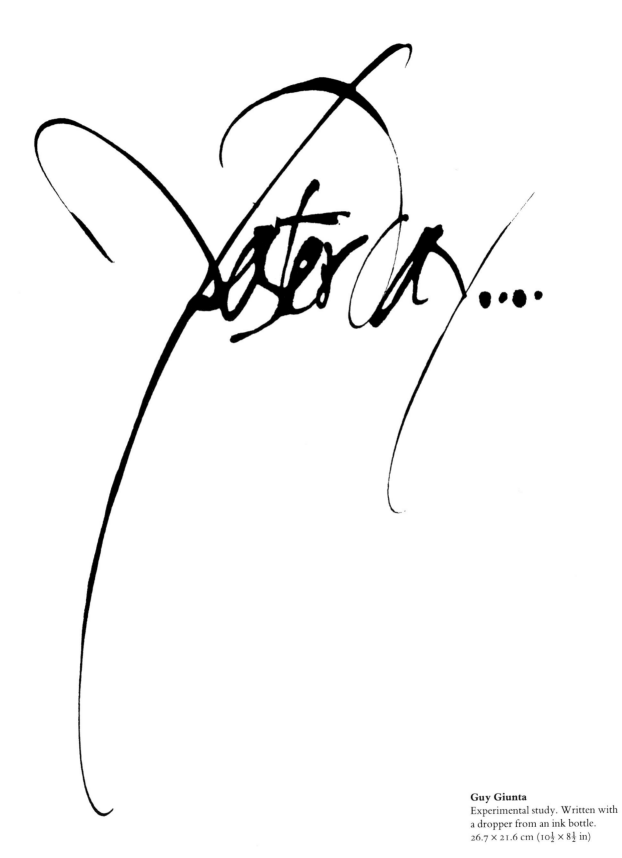

Guy Giunta
Experimental study. Written with
a dropper from an ink bottle.
26.7 × 21.6 cm ($10\frac{1}{2}$ × $8\frac{1}{2}$ in)

27

Darin besteht
das Wesen der Tugend,
daß du in Freuden
und in Leiden Thomas
v. Kempen
ein und derselbe
Mensch bist.

Alfred Linz
Quotation from Thomas a
Kempis. Ink on white paper for the
Erwin-Stauber-Verlag.
14.5 × 8 cm (5¾ × 3¼ in)

El que beve se emboracha.
El que se emboracha duerme.
El que duerme non peca.
El que non peca va al cielo.
Presto que al cielo vamos
Bevemos, bevemos

SPANISH FOLK SONG

Jovica Veljović
'Spanish Folk Song'. Calligraphy
for the Taplinger calendar 1984.
Written with a metal pen on paper.
36 × 25 cm (14⅛ × 9⅞)

Б

у · Буквару

на Бубрило

да · Букне

као · Барут

као · Бом Ба

у · Бубњу · опну

Буди Богснама!

Буљук

Баба

Буљи · у

Бок

цаБа:

Бу Ба

Буквар · у

Буџаку

а Ба

ДУШАН ЛАДОВИК

ВУКОВА АЗБУКА

Jovica Veljović
'About letter Б'. Lettered in
Cyrilic with metal pens and reeds
on watercolour paper in different
colours. Property of Florence
Burns. 36 × 48 cm ($14\frac{1}{8} \times 18\frac{7}{8}$ in)

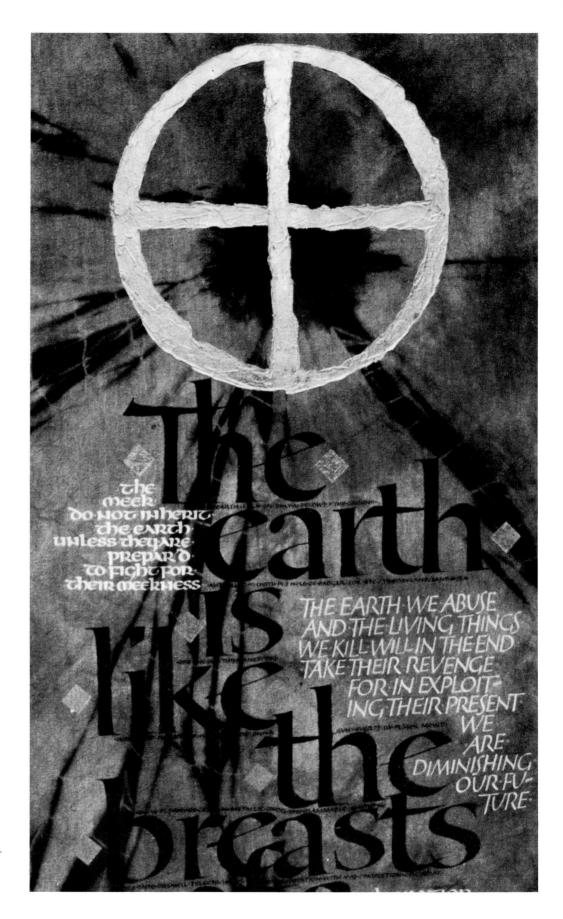

Charles Pearce
'Earth' from 'The Four Elements'.
Acrylic on dyed cotton duck
canvas with copper leaf.
24 × 72 cm (9½ × 28⅜ in)

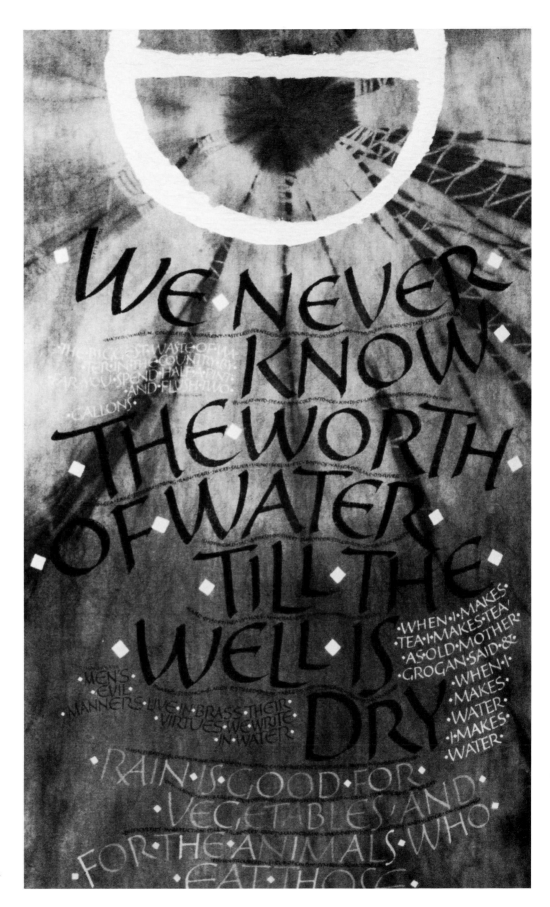

Charles Pearce
'Water'. Acrylic on dyed cotton
duck canvas, detail picked out with
gold leaf. 24 × 72 cm (9½ × 28⅜ in)

Ann Hechle
'In the beginning'. Written with quills and steel pens, raised and burnished gold leaf and powder gold. 35 × 25 cm (14 × 10 in)

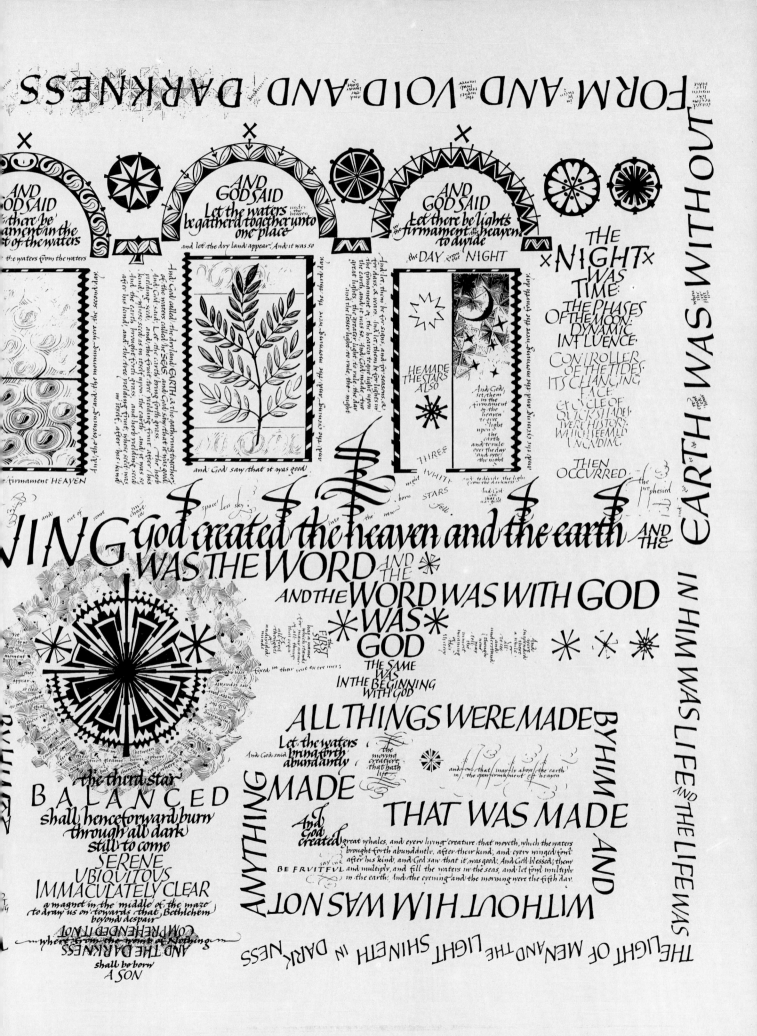

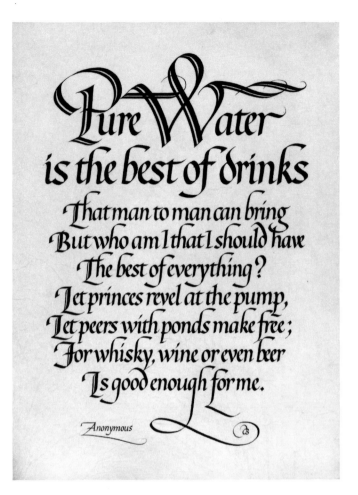

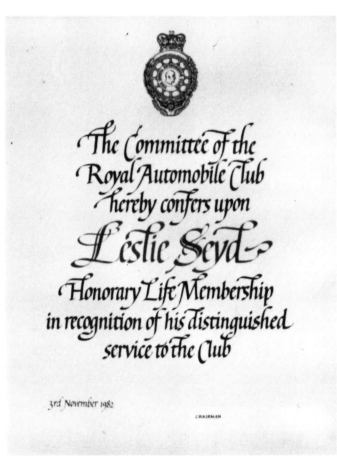

Derek Benney
'Pure Water'. Watercolour and
Chinese ink on vellum.
32.4 × 24.1 cm (12¾ × 9½ in)

Marcy Robinson
Scottish prayer. Written with a
Speedball 'C' series nib in Chinese
stick ink.

John Woodcock
Address for the RAC. Watercolour
and black ink on vellum.
28 × 36 cm (11 × 14⅛ in)

ARMS OF THE
PRIME WARDENS
OF THE WORSHIPFUL
COMPANY OF
FISHMONGERS

VOLUME
FOUR

Left and below right
Wendy Westover
Two pages from Volume 4 of the
Books of Record of the Prime
Wardens of the Worshipful
Company of Fishmongers.
Written in Chinese stick in,
gouache and powder colours on
vellum. 24.2 × 13.8 cm (9½ × 5½ in)

Marcy Robinson
Quotation from Shakespeare's
King John Act 3, Scene 1. Written
in Chinese liquid stick ink with a
Speedball 'C' series nib.

The glorious sun
stays in his course,
KING JOHN
ACT 3 · SC.1 and plays the
alchymist: turning
with splendor of
his precious eye
the meagre WILLIAM
SHAKESPEARE
cloddy earth to
glittering gold:

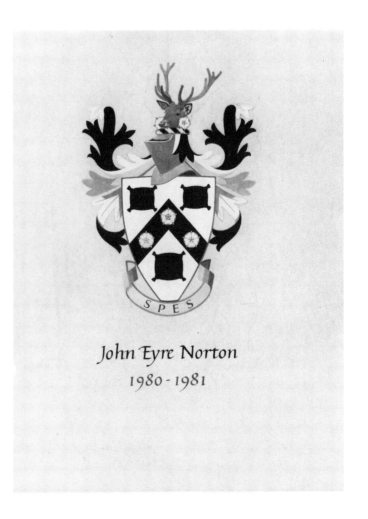

John Eyre Norton
1980 - 1981

Aleksander Dodig
Cyrilic lettering written in tempera
with brush and nib on coloured
paper. 49.5 mm × 31 mm

Facing page
David Mekelburg
'To what serves mortal beauty ?'
Poem by Gerard Manley Hopkins.
Lettered in Chinese stick ink, with
the title in dark green designers
gouache with accents in vermilion
stick ink on Whatman paper. From
the Harrison Collection, San
Francisco. 50.8 × 66 cm (20 × 26 in)

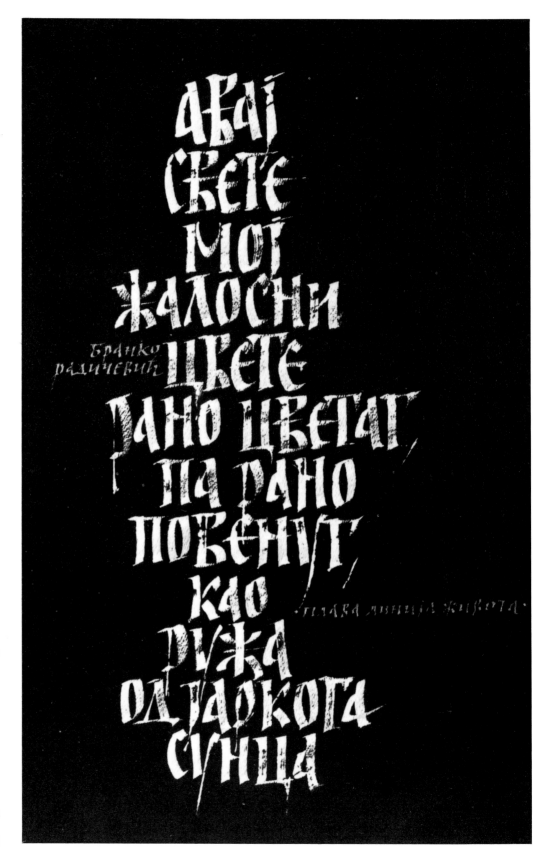

TO WHAT SERVES MORTAL BEAUTY?

To what serves mortal beauty—dangerous; does set danc-
 ing blood-the O-seal-that-so feature, flung prouder form
Than Purcell tune lets tread to? See: it does this: keeps warm
Men's wits to the things that are; what good means—where a
 glance
Master more may than gaze, gaze out of countenance.
Those lovely lads once, wet-fresh windfalls of war's storm,
How then should Gregory, a father, have gleaned else from
 swarm—
 ed Rome? But God to a nation dealt that day's dear chance.
To man, that needs would worship block or barren stone,
Our law says: Love what are love's worthiest, were all known;
World's loveliest—men's selves. Self flashes off frame and face.
What do then? how meet beauty? Merely meet it; own,
Home at heart, heaven's sweet gift; then leave, let that alone.
Yea, wish that though, wish all, God's better beauty, grace.

GERARD MANLEY HOPKINS Written out by David Mekelburg

37

In BOOKS
lies the Soul
of the whole
of Past Time.
All that
Mankind
has done,
thought,
gained or
been: it is
lying as in
magic
preservation
in the pages
of Books

Thomas Carlisle

Sheila Waters
Quotation from Thomas Carlyle.
Written with a number 3 Mitchell
'Cursive' nib. Actual size

All the flowers of the spring
Meet to perfume our burying;
These have but their growing prime,
And man does flourish but his time.
Survey our progress from our birth—
We are set, we grow, we turn to earth.
Courts adieu, and all delights,
All bewitching appetites!
Sweetest breath and clearest eye
Like perfumes go out and die;
And consequently this is done
As shadows wait upon the sun.
Vain the ambition of kings
Who seek by trophies and dead things
To leave a living name behind,
And weave but nets to catch the wind.

✦ J O H N ✦ W E B S T E R ✦

Joan Pilsbury
Poem by John Webster. Written in
black stick ink with one burnished
gold initial, and John Webster in
blue, on mounted vellum.
38.1 × 24.8 cm (15 × 9¼ in)

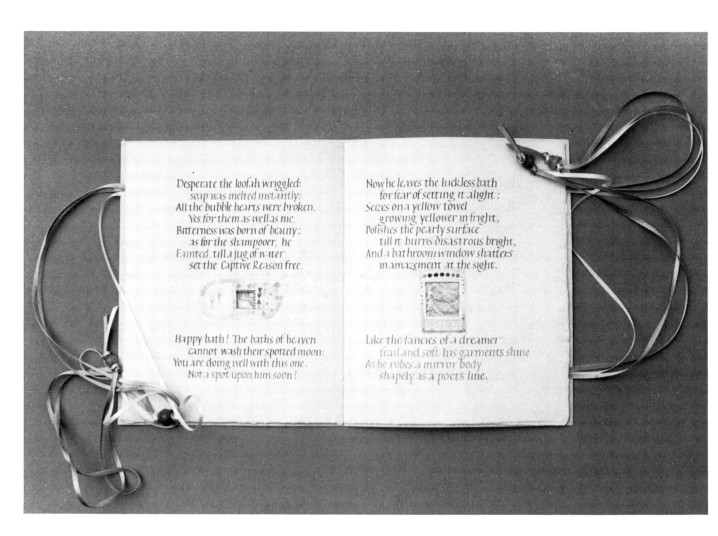

Desperate the loofah wriggled:
 soap was melted instantly:
All the bubble hearts were broken.
 Yes for them as well as me.
Bitterness was born of beauty;
 as for the shampooer, he
Fainted, till a jug of water
 set the Captive Reason free.

Happy bath! The baths of heaven
 cannot wash their spotted moon:
You are doing well with this one.
 Not a spot upon him soon!

Now he leaves the luckless bath
 for fear of setting it alight;
Seizes on a yellow towel
 growing yellower in fright,
Polishes the pearly surface
 till it burns disastrous bright,
And a bathroom window shatters
 in amazement at the sight.

Like the fancies of a dreamer
 frail and soft his garments shine
As he robes a mirror body
 shapely as a poet's line.

Alison Urwick
'The Hammam Name', by
J E Flecker. Painted and written in
gouache and watercolours. Holes
are cut in the pages right through
the book. 18.9 × 15.9 cm
(7½ × 6¼ in)

Georgia Deaver
Single page from manuscript book.
Written with quills and using stick
ink, gouache and gum ammoniac.

The green-swathed
grasshopper, on treble pipe
Sings there, and dances,
in mad-hearted pranks
There bees go courting
every flower that's ripe
On baulks and sunny banks:
And droning dragon-fly,
on rude bassoon.
Attempts to give God
thanks
In no discordant
tune.

The speckled thrush,
by self-delight imbued
There sings unto himself
for joy's amends.
And drinks the honey-dew
of solitude.
There Happiness attends
With inbred Joy until the heart
O'erflow.
Of which the world's rude
friends
Naught heeding,
nothing know.

The pranking cat its
flighty circlet makes:
The glow-worm
burnishes
its lamp anew,
O'er meadows dew-
besprent;
the beetle wakes-
Inquiries ever new
Teasing each
passing ear
with murmurs vain.
As wanting
to pursue
His homeward
path again,

Hark! 'tis the melody
of distant bells
That on the wind with
distant hum
rebounds
By fitful starts then
musically swells
O'er the dim, stilly
grounds;
While on the meadow-
bridge
the passing boy
Listens the mellow
sounds
And hums,
in vacant joy.

Pat Russell
'Summer Images'. Quotation from John Clare. Written in changing tones of coloured inks on stone-coloured Japanese paper. Trial page for a manuscript book. 28 × 38 cm (11 × 15 in)

'Summer Images'. Quotation from John Clare. Brown ink on Japanese paper. Trial page for a manuscript book. 20 × 47 cm ($7\frac{7}{8} \times 18\frac{1}{2}$ in)

41

Brody Neuenschwander
'A brief history of Princeton University'. Letters in gold leaf applied over a mixture of gum ammoniac, gum arabic and sugar on white Chatham vellum handmade paper. 24.2 × 24.9 cm (9½ × 13¾ in)

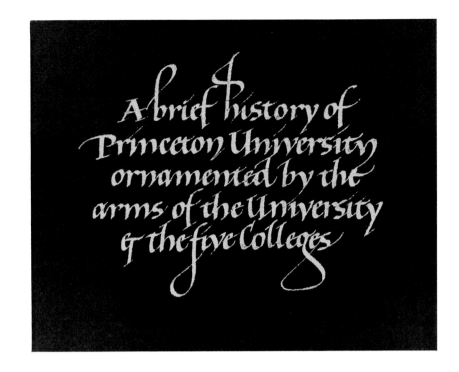

Ruth Bruckner
Psalm 137. Written with a metal pen, stick ink and designers gouache on Chatham vellum paper. 63 × 50 cm (24¾ × 19¾ in)

Facing page, top
Robert Williams
'Virginia Woolf meets Robert Graves' from Virginia Woolf's diary. By courtesy of the Estate of Virginia Woolf. Ink and gouache on paper. Bound by the scribe. 22.2 × 16 cm (8¾ × 6¼ in)

Facing page, bottom
Stan Knight
'Antarctica'. Spread from a book commemorating Captain Scott's journey to the South Pole. Quotation from Psalm 104. Executed in watercolour and Chinese stick ink. The image is based on a photograph taken on the Scott expedition by Herbert Ponting. Spread size 35.6 × 50.8 cm (14 × 20 in)

By the rivers of Babylon there we sat down,
yea, we wept, when we remembered Zion.
We hanged our harps upon the willows in the midst thereof.
For there they that carried us away captive required of us a song;
and they that wasted us required of us mirth,
saying, sing us one of the songs of Zion.
How shall we sing the Lord's song in a strange land?

If I forget thee, O Jerusalem,
let my right hand forget its cunning.

If I do not remember thee, let my tongue
cleave to the roof of my mouth;
if I prefer not Jerusalem above my chief joy.
Remember, O Lord, the children of Edom in the day of Jerusalem;
who said, rase it, rase it, even to the foundation thereof.
O daughter of Babylon, who art to be destroyed;
happy shall he be, that rewardeth thee as thou hast served us.
Happy shall he be, that taketh and
dasheth thy little ones against the stones.

PSALM 137

The poor boy is all emphasis protestation & pose. He has a crude likeness to Shelley save that his nose is a switch back & his lines blurred.

But consciousnes of genius is bad for people. He stayed till 7.15 (we were going to Caesar & Cleopatra–a strange rhetorical romantic early Shaw play) & had at last to say so, for he was so thick in the delight of explaining his way of life to us that no bee stuck faster to honey. He cooks, his wife cleans; 4 children are brought up in the elementary school; the villagers give them vegetables; they were married in Church; his wife calls herself Nancy Nicolson; won't go to Garsington, said to him I must have a house for nothing; on a river; in a village with a square church tower; near but not on a railway–all of which, as she knows her mind, he procured. Calling herself Nicolson has sorted her friends into sheep & goats. All this to us sounded like the usual self consciousness of young men, especially as he threw in, gratuitously, the information that he descends from dean rector, Bishop, Von Ranker & & &: only in order to say that he despises them.

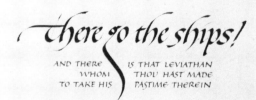

there go the ships!

AND THERE WHOM TO TAKE HIS IS THAT LEVIATHAN THOU HAST MADE PASTIME THEREIN

Stan Knight
'Raw and cold is icy Spring'. Irish verse, by an unknown 11th century poet. One of four panels representing the four seasons. Written and painted on Arches aquarelle paper in watercolour with occasional use of masking fluid. 40 × 26 cm (15¾ × 10¼ in)

Facing page
Thomas Ingmire
'Without Warning'. Sumi ink, watercolour, gouache, gold leaf and gold powder. 45.7 × 61 cm (18 × 24 in)

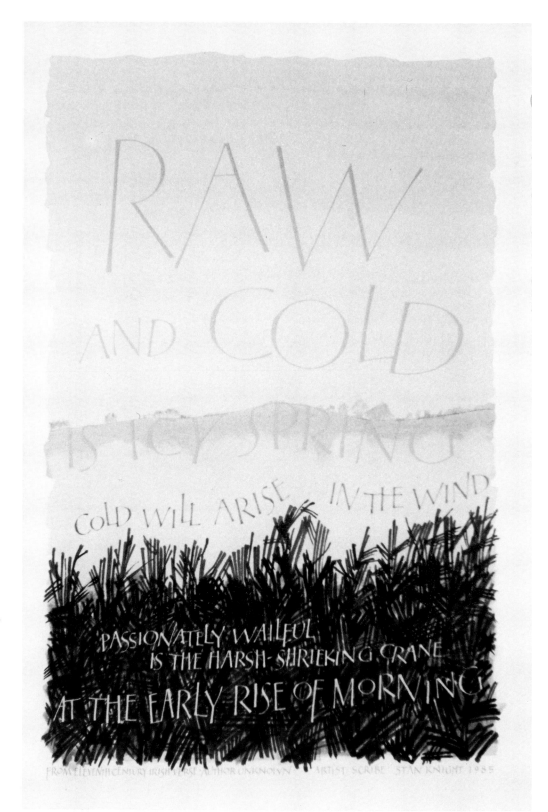

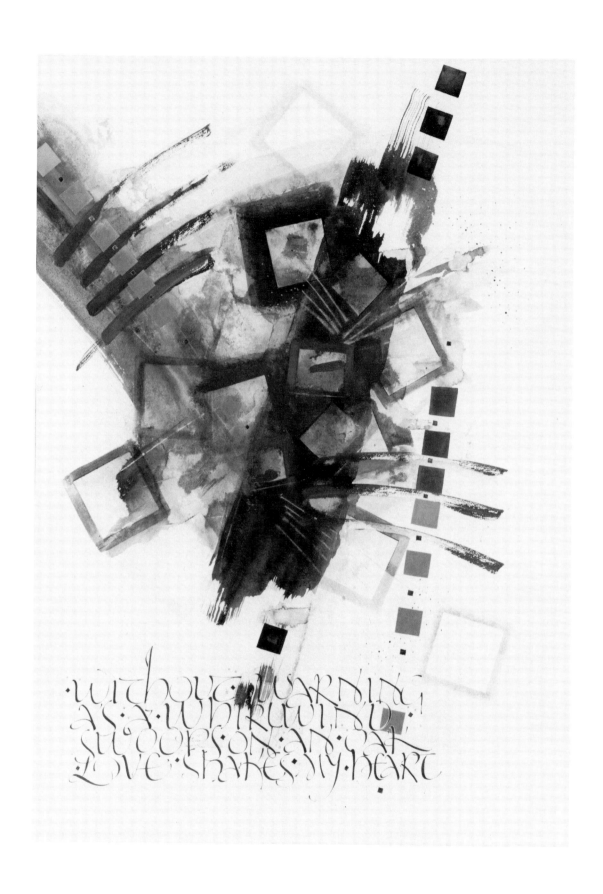

without warning
as a whirlwind
swoops on an oak
Love shakes my heart

45

Alan Blackman
Two first day covers written with a steel pen and Japanese stick inks on Crane's Kidfinish white envelopes. 10.2 × 19 cm (4 × 7½ in)

Thomas Ingmire
'Do not go gentle'. Panel with a quotation based on a poem by Dylan Thomas. Sumi ink, watercolour, gouache, gold leaf and powder gold on Edmonds paper. 25.4 × 68.6 cm (10 × 27 in)

Facing page
Thomas Ingmire
'The beloved stranger lives'. Quotation from Denise Levertov. Sumi ink, gouache, and gold leaf on Edmonds paper. 45.7 × 61 cm (18 × 24 in)

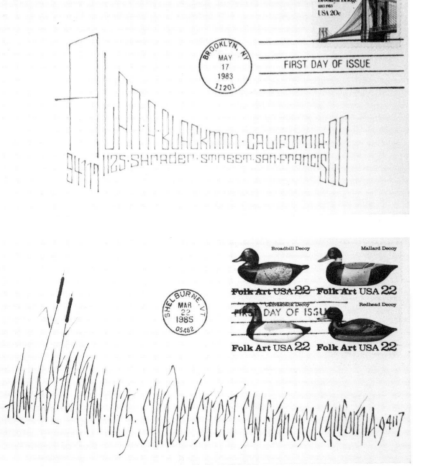

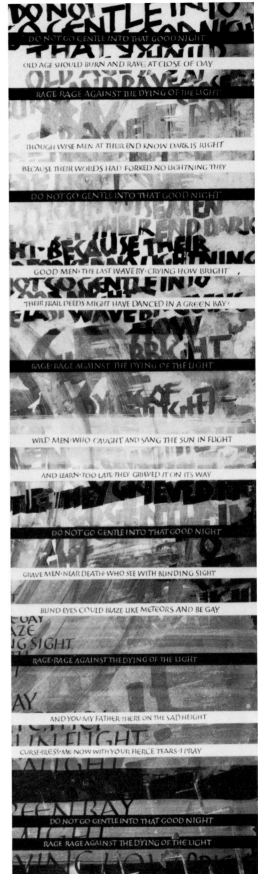

46

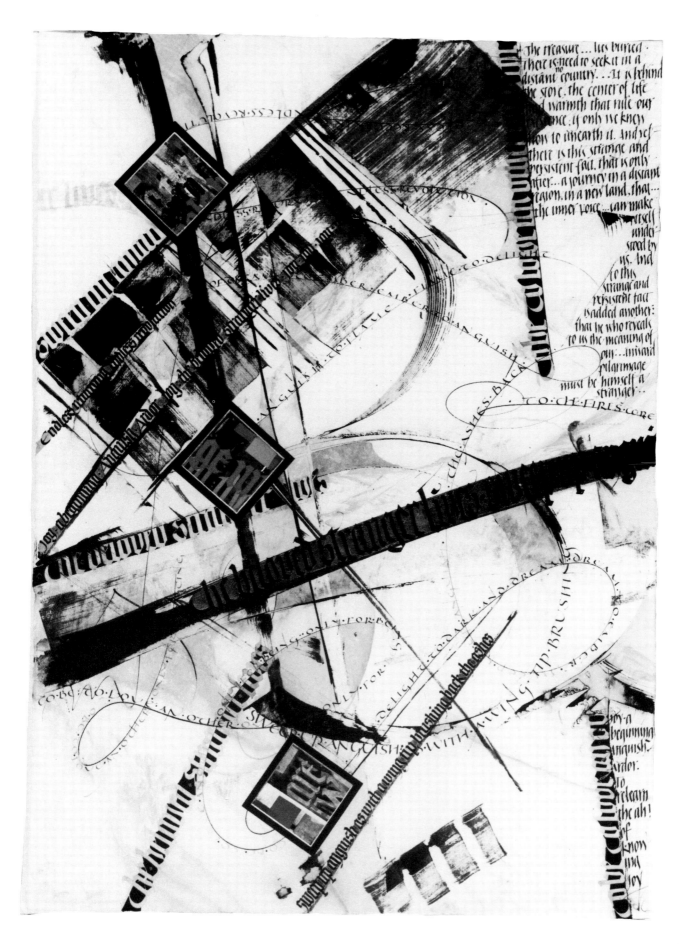

The treasure ... lies buried. There is need to seek it in a distant country ... It is behind the stove, the center of life and warmth that rule our existence. if only we knew how to unearth it. And yet there is this strange and persistent fact. that is only hinted ... a journey in a distant region. in a new land. that ... the inner voice ... can make itself understood by us. And to this strange and persistent fact is added another: that he who reveals to us the meaning of our ... inward pilgrimage must be himself a stranger ...

47

Christine Oxley
Book of donors for Hereford
Cathedral. Handmade paper
lettered in blue gouache.
33 × 26.7 cm (13 × 10½ in)

John Stevens
'We are made wise'. Quotation
from George Bernard Shaw.
Written in black stick ink and red
gouache, with a steel pen on
Fabriano paper. Width of original
30.5 cm (12 in)

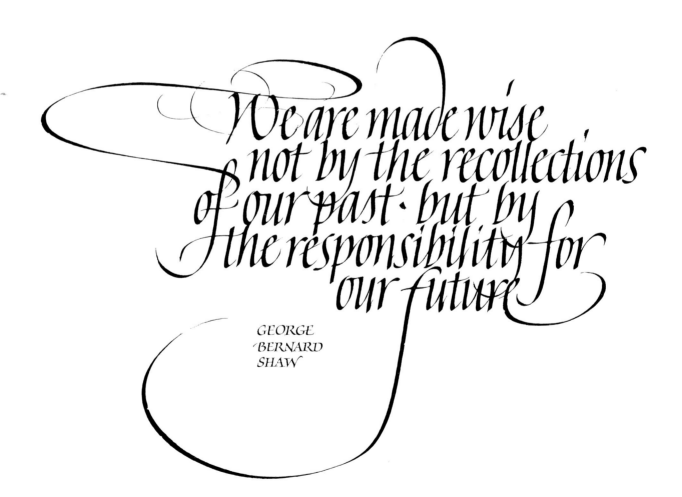

Stuart Barrie
Quotation from Horace. Written
with an automatic pen and
Mitchell black and two ochres.
35.6 × 24.1 cm (14 × 9½ in)

Kennedy Smith
'The Lark'. Freely written in
gouache with quills on vellum,
gold leaf and gold powder.
31.8 × 12.7 cm (12½ × 5 in)

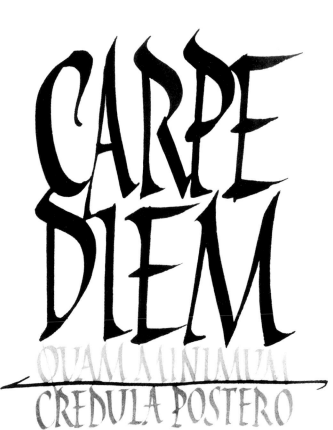

CARPE
DIEM
QUAM MINIMUM
CREDULA POSTERO

HORACE

Seize today
and put as little trust as you can
in the morrow

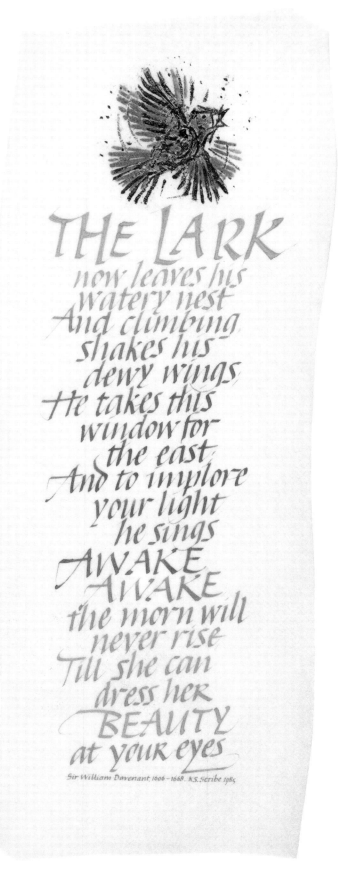

THE LARK
now leaves his
watery nest
And climbing
shakes his
dewy wings
He takes this
window for
the east
And to implore
your light
he sings
AWAKE
AWAKE
the morn will
never rise
Till she can
dress her
BEAUTY
at your eyes

Sir William Davenant 1606 – 1668 . K.S. Scribe 1985

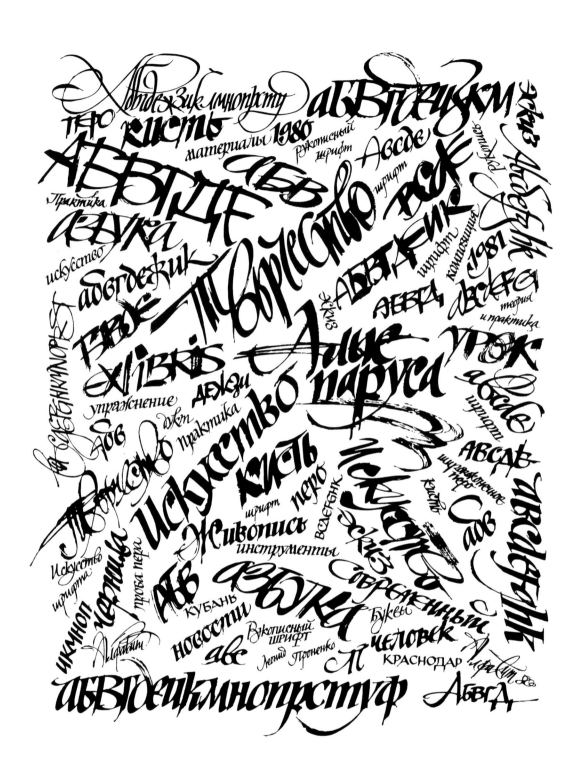

Leonid Pronenko
'Alexander'. Calligraphic composition.

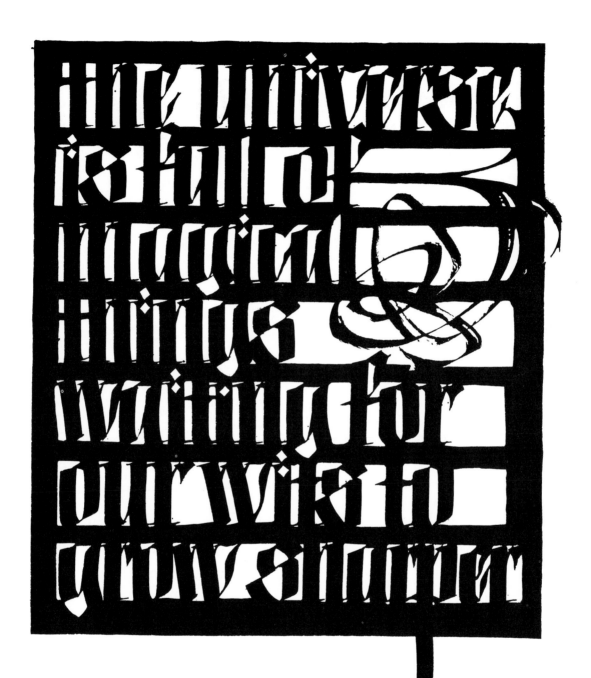

the universe is full of magical things writing for our minds to grow sharper

from a Chinese fortune cookie

Nancy Culmone
'Friend'. Written with a reed in
Sumi ink on Strathmore charcoal
paper. 43.2 × 30.5 cm (17 × 12 in)

Peter Halliday
Two poems by EE Cummings.
Left 'mi(dreamlike)st'. Chinese ink
on handmade paper. © 1961 by EE
Cummings. 14.4 × 10.5 cm
(36.8 × 4⅛ in).
Right '(fea'. Chinese ink on
handmade paper. © 1950 by EE
Cummings; 1978 by the EE
Cummings Trust. 14.5 × 10.5 cm
(36.8 × 4⅛ in)

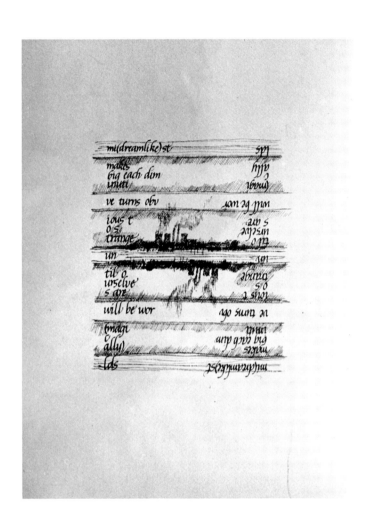

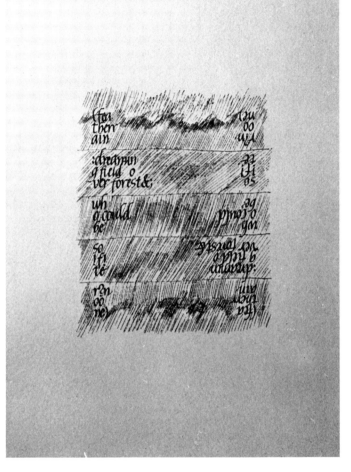

Claude Dietrich
Quotation from Heraclitus.
Written out in Sumi ink on
handmade paper, with raised and
burnished gold. 35 × 35 cm
(13¾ × 13¾ in)

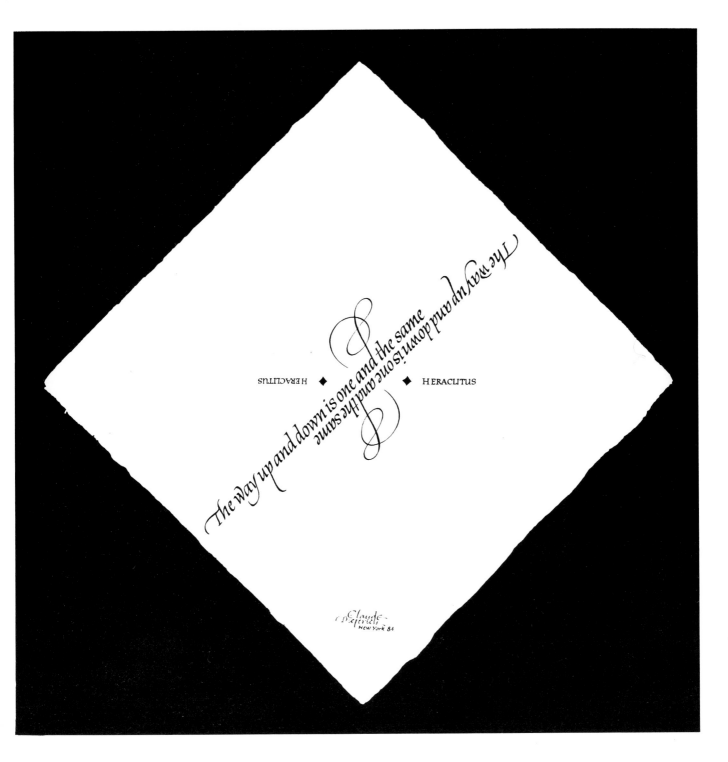

Bonnie Spiegel
'Without protest.' Sumi ink and red gouache. 43.2 × 55.9 cm (17 × 22 in)

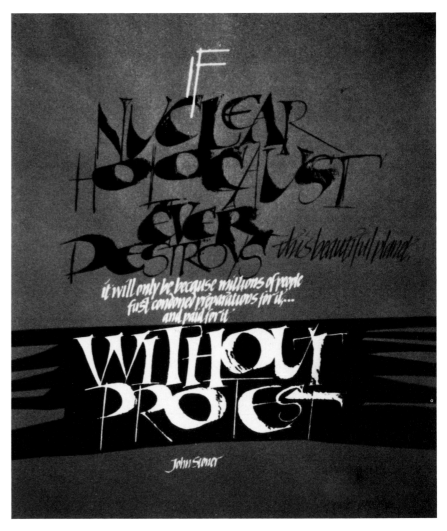

Vera Ibbett
Quotation from Virgil. Single stroke brush with screen overlay. Width of lettering 20.3 cm (8 in)

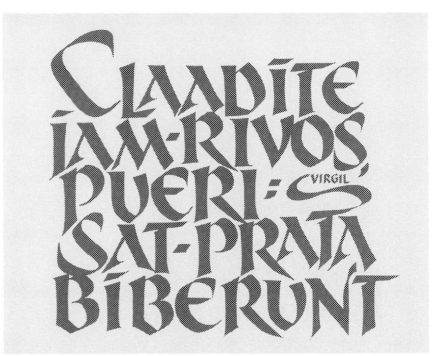

Facing page
Mark Van Stone
'Phoenician Wa'. Embossed watercolour with Sumi ink, brush, in green, blue and purple on rag paper. 20.3 × 25.4 cm (8 × 10 in)

WREN WARBLERS ARE TINY BIRDS

many of which are brightly coloured in contrasting shiny blues, reds, blacks and whites. They carry their long tails perpetually cocked up over the back in wren fashion, most are good singers and a few are clever mimics. They are usually encountered in small flocks even during the breeding season.

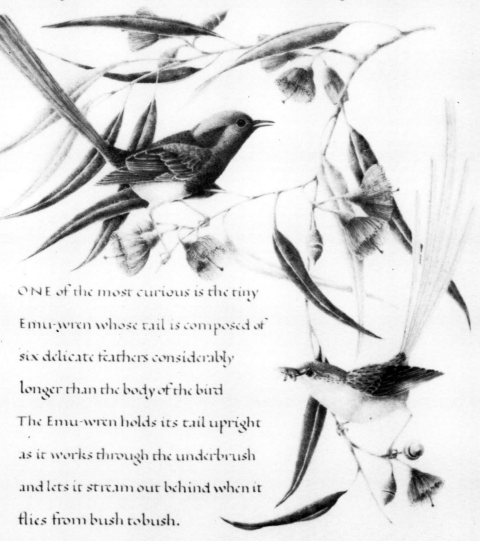

ONE of the most curious is the tiny Emu-wren whose tail is composed of six delicate feathers considerably longer than the body of the bird. The Emu-wren holds its tail upright as it works through the underbrush and lets it stream out behind when it flies from bush to bush.

Thomas Laudy
'I hear the muses'. Poem by
J B Houwaert (1533–1599).
Lettered in black with a
Soenneckaen pen. The initial is in
vermilion on Oxford creme paper.
42 × 30 cm (16½ × 11¾ in)

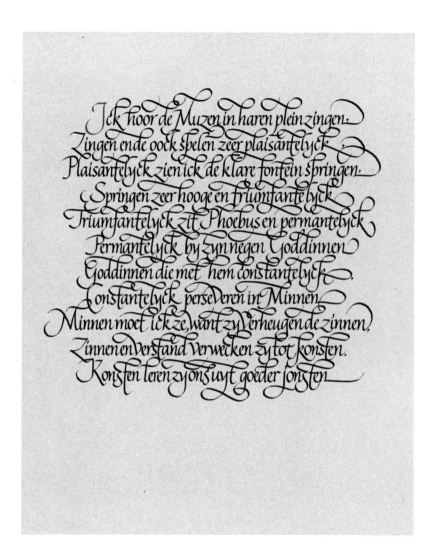

Martin Wilke
'Homage'. Written with a Joseph
Gillott extra fine pen. Width of
lettering 24 cm (9½ in)

Facing page
John Stevens
The word 'scribe' is written with a
watercolour brush in white
gouache, everything else is pen
written, on black Canson paper.

SCRIBE

THE SCRIBE SHOULD CHOOSE THE BEST AND
SIMPLEST FORMS AND ARRANGEMENTS
AND MASTER THEM BEFORE GOING FURTHER; HE
SHOULD HAVE "A FEW DEFINATE TYPES AT HIS
FINGER TIPS" AND FOR EVERYDAY USE
A MATTER OF COURSE" WAY OF PUTTING THEM
DOWN ON PAPER • AMBIGUITY IS ONE OF THE
GREATEST FAULTS IN A CRAFT.
IT COMES OFTEN FROM VAGUE AMBITIONS.
ONE MAY BE INSPIRED BY GOOD
AMBITIONS, BUT THE IMMEDIATE CON-
"CERN OF THE CRAFTSMAN IS TO KNOW WHAT HE
CAPABLE OF DOING AT PRESENT, AND TO DO IT.
"LET THE MEANING OF YOUR WORK BE
OBVIOUS UNLESS IT IS DESIGNED PURELY FOR YOUR
OWN AMUSEMENT. A GOOD CRAFTSMAN
SEEKS OUT THE COMMONPLACE AND TRIES TO
MASTER IT, KNOWING THAT "ORIGINALITY" COMES
OF NECESSITY, AND NOT OF
SEARCHING.

Edward Johnston

1906 WRITING · ILLUMINATING · LETTERING

GEOMETRY
CAN PRODUCE
LEGIBLE LETTERS,
BUT ART
ALONE MAKES
THEM BEAUTIFUL.
ART BEGINS
WHERE GEOMETRY
ENDS,
IMPARTS TO LETTERS
A CHARACTER
TRANSCENDING
MERE
MEASUREMENT

PAUL STANDARD

Werner Schneider
Written with a HIRO note pen
and Chinese ink on a Roma-Butten
paper. 48 × 65 cm (19 × 25⅝ in)

FOUR SEASONS FILL THE
MEASURE OF THE YEAR
There are four seasons in the mind of man:
He has his lusty SPRING when fancy clear
Takes in all beauty with an easy span:
He has his SUMMER when luxuriously
Spring's honied cud of youthful thought he loves
To ruminate and by such dreaming high
Is nearest unto heaven: quiet coves
His soul has in its AUTUMN when his wings
He furleth close contented so to look
On mists in idleness – to let fair things
Pass by unheeded as a threshold brook.
He has his WINTER too of pale misfeature
Or else he would forego his mortal nature.

JOHN KEATS: ON THE HUMAN SEASONS: 1818

Susie Taylor
'On the Human Seasons'.
Quotation from Keats's poem.
Gouache on Ingres paper, steel
nibs. 27.9 × 35.6 cm (11 × 14 in)

John Woodcock
'The Beauty of a Letter'.
Quotation from Frederic W.
Goudy *The Alphabet and Elements of Lettering* originally published by University of California Press 1952, and by Dover Publications Inc in 1963. The centre panel is lettered in brown ink with a metal pen on Whatman paper. The large border has brush drawn letters in gouache resist on a yellow, brown, and green background of Barcham Green paper mounted on 4-sheet card. The outer border is in similar colours, pen lettered, with masking-fluid resist and mounted on 4-sheet card. 48.4 × 56.5 cm (19 × 22¼ in)

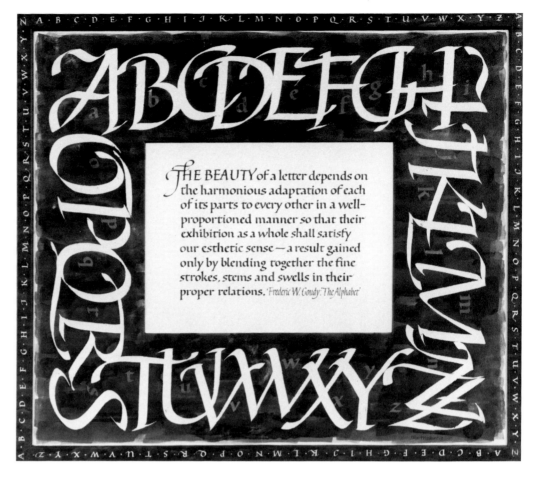

THE BEAUTY of a letter depends on the harmonious adaptation of each of its parts to every other in a well-proportioned manner so that their exhibition as a whole shall satisfy our esthetic sense — a result gained only by blending together the fine strokes, stems and swells in their proper relations. *Frederic W. Goudy, The Alphabet*

John Stevens
Alphabet and quotations commissioned for G. Rodriguez. Black stick ink in maroon, grey and turquoise on Michaelangelo paper. 48.3 × 73.7 cm (19 × 29 in)

Facing page
Martin Jackson
Panel to commemorate the 150th anniversary of the birth of William Morris. The original written on Saunders cold pressed 140 lb paper using Chinese stick ink and bamboo pens. Cerulean blue, with gilded dots between the letters. 26 × 20 cm (10¼ × 8 in)

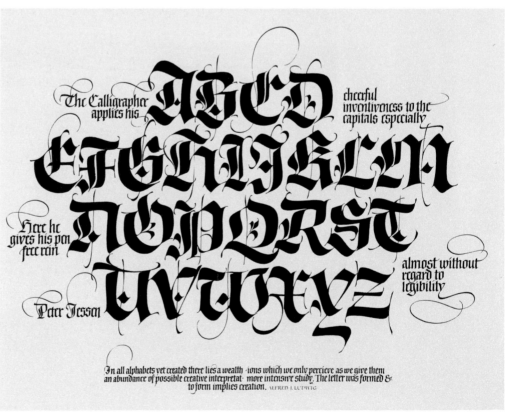

W·I·L·L·I·A·M

BORN·MARCH·24·EIGHTEEN·THIRTY·FOUR

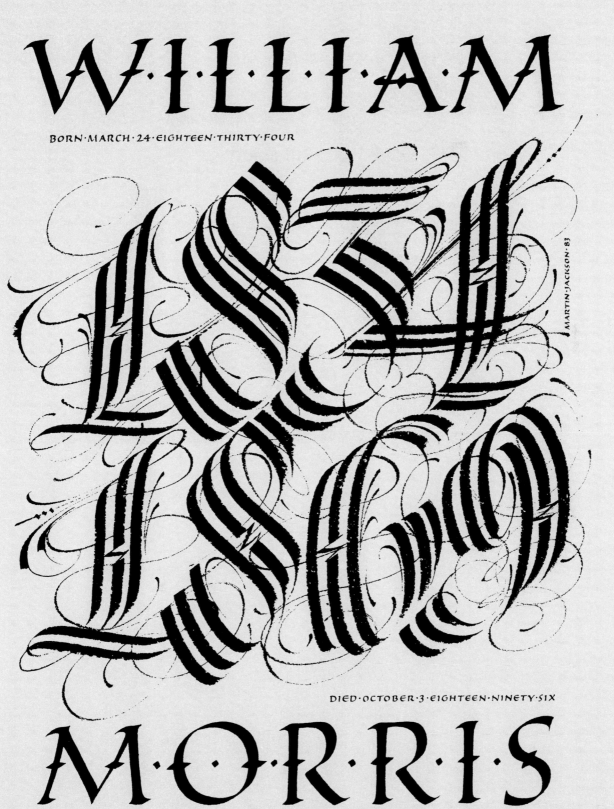

DIED·OCTOBER·3·EIGHTEEN·NINETY·SIX

M·O·R·R·I·S

Dear William, this humble scribe apologises most sincerely for reducing your life by 27 years.

Colleen
Alphabet. Written in black
permanent felt tip marker on
cream Strathmore Pastelle.
24.1 × 21.3 cm (9½ × 8⅜ in)

Facing page
Lindsay Castell
Palm leaf style book. Written with
reeds in red gouache and black ink
on India Office paper. 9 × 31.5 cm
(3½ × 12⅜ in)

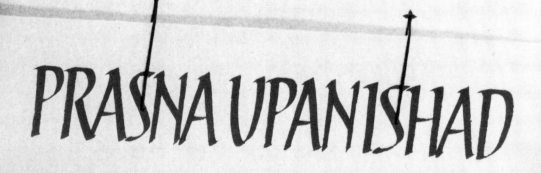

PRASNA UPANISHAD

SECOND QUESTION·THEN BHARGAVA VAIDARBHI ASKED:
MASTER, WHAT ARE THE POWERS THAT KEEP THE UNION
OF A BEING, ✦ HOW MANY KEEP BURNING ✦ THE LAMPS
OF LIFE, AND WHICH AMONGST THEM IS SUPREME?
THE SAGE REPLIED: THE POWERS ARE SPACE, AIR, FIRE,

BEING AND ~~~~~~~~~~
HIM NOT. ✦ LIFE WAS OFFENDED AND ✦ ~~ROSE~~
TO LEAVE THE BODY, AND ALL THE POWERS OF LIFE HAD
TO RISE AND, LIFE COMING AGAIN TO REST, ALL THE POW-

SKY. LIFE IS WATER ~~~~~~~~~~
IS NOT, AND WHAT BEYOND IS IN ETERNITY. ON LIFE ALL

Stuart Barrie
Quotation attributed to Julius
Caesar. Drawn lettering in yellow
ochre, grey and black on
handmade paper. 27.9 × 17.8 cm
(11 × 7 in)

Kevin Horvath
Vertical alphabet. Speedball flat
pen on Strathmore paper. Original
size 19 × 40.6 cm (7½ × 16 in)

IT IS Better
to DIE once
THAN LIVE
ALWAYS
IN fEAR
of DEATH

JULIUS CÆSAR

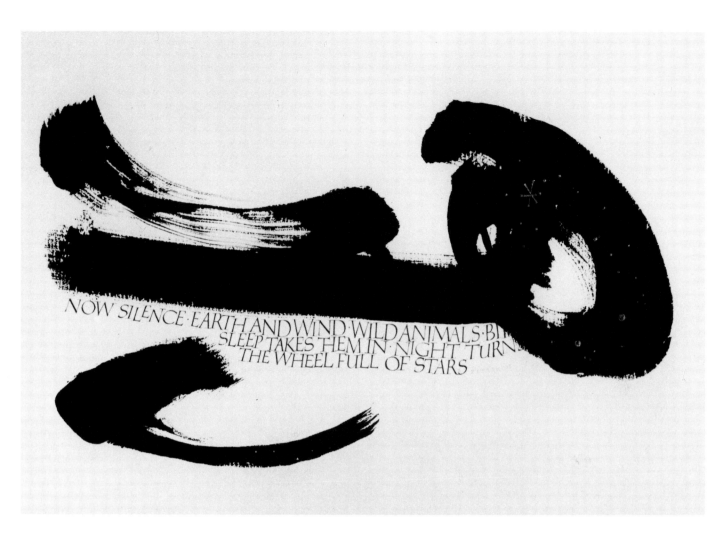

Jeff Jeffreys
'Now Silence'. Quotation from
Petrarch. Executed in Chinese stick
ink, gouache, gold on gum
ammoniac and gesso, brush and
steel nibs on Fabriano paper.
33×48 cm ($13 \times 18\frac{7}{8}$ in)

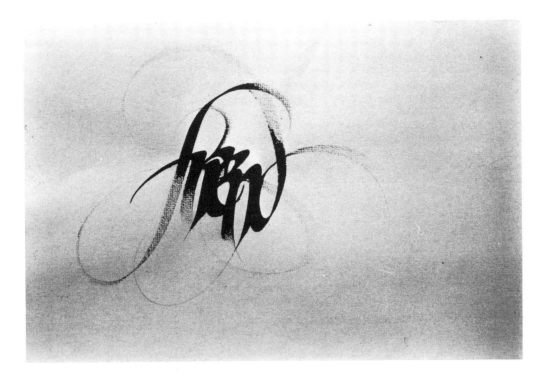

Nancy Culmone
'Friend'. Written with a reed in
Sumi ink on Strathmore charcoal
paper. 43.2 × 30.5 cm (17 × 12 in)

David Howells
'Japanese ABC'. Pen and ink.
16.5 × 14 cm (6½ × 5½ in)

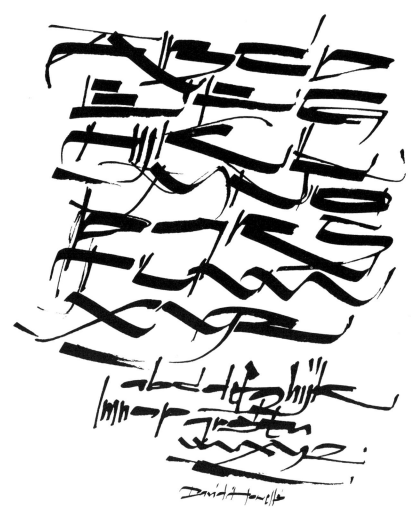

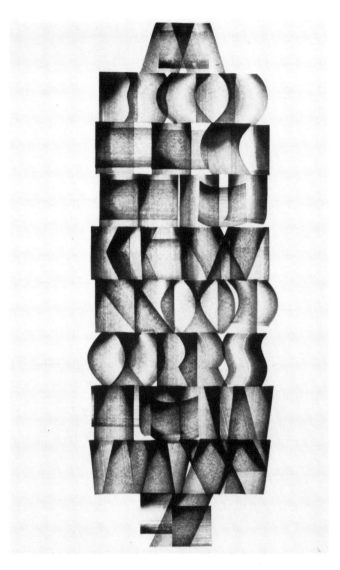

Nancy Ouchida–Howells
'Monolith Needle'. Watercolour
written with card on paper.
42 × 108 cm (16½ × 42½ in)

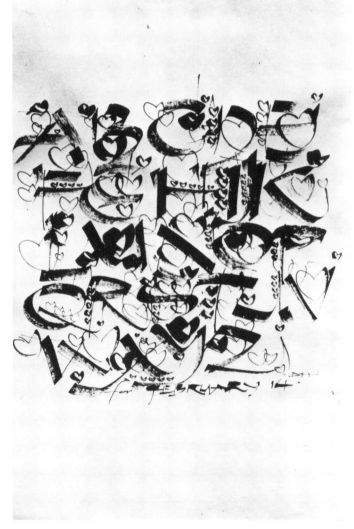

David Howells
Valentine Alphabet. Written in
pen and watercolour on handmade
paper. 30.5 × 30.5 cm (12 × 12 in)

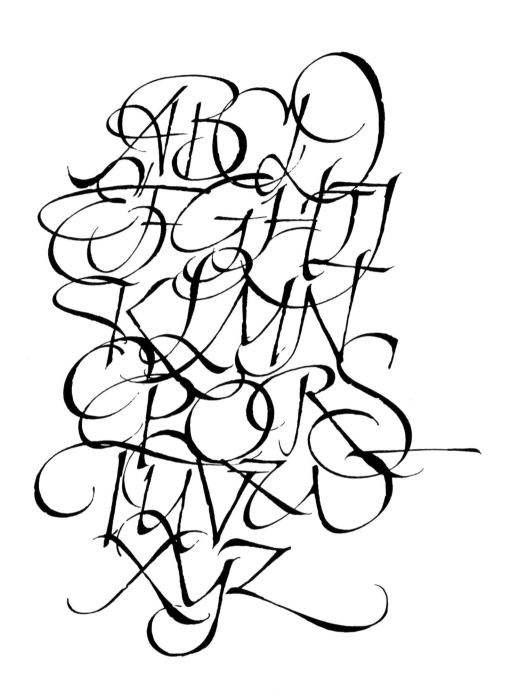

Kevin Elston
Alphabet. Pen on watercolour paper

Calligraphy and lettering for reproduction

Lubomír Krátky
Screen print on paper. Written on handmade paper with a flat-edged pen. 30 × 24 cm (11¾ × 9½ in)

Peter Noth
Wedding monogram. Made with a Shaeffer cut out pen. Width of the letters 14 cm (5½ in)

Adrian Frutiger
Double page spread from *Lettering: the development of European letter types carved in wood* by Adrian Frutiger. Verso: Roman Semi-Cursive, 4th century. Recto: Rustic capitals, 4th–5th century. Page size 28 × 14.9 cm (11 × 5⅞ in)

Paul Maurer
'The Supreme Misfortune'.
Created for commercial
reproduction. Metal pens,
compass, photostats. 15×19.5 cm
($5\frac{7}{8} \times 7\frac{5}{8}$ in)

Donald Jackson
'Painting with words', logo for a
Paris exhibition of calligraphic
works. Written with a quill. Width
of lettering 22 cm ($8\frac{5}{8}$ in)

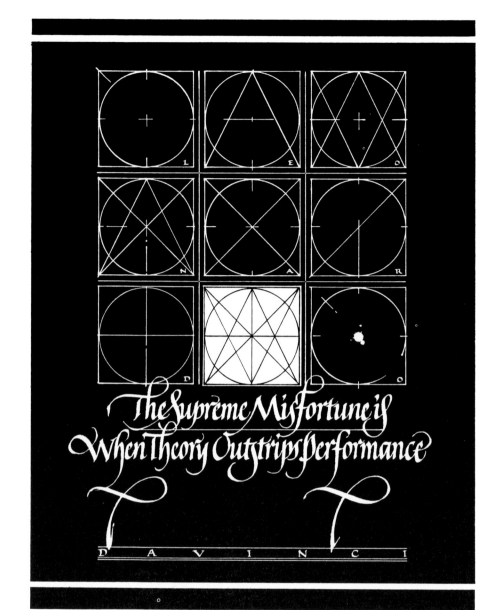

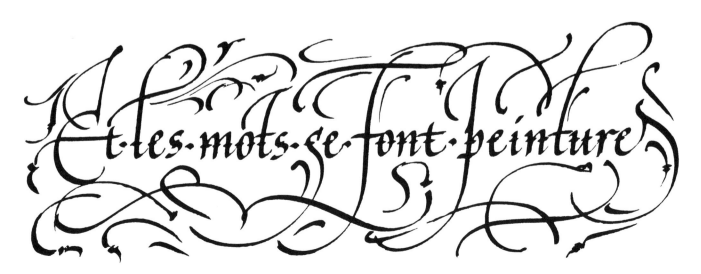

Work thou for pleasure!

Sing
or paint or carve
the thing
thou lovest.
Though the body
starve!
Who works for GLORY
misses oft the goal;
Who works for MONEY
coins his very soul.

Work for the Work's
sake
then,

And it may be
that these things
may be added
unto thee

KENYON
COX
The Gospel of Art
1895

Jenny Groat
Offset print in blue and black with
hand brushwork in shades of ochre,
orange and yellow. 25.4 × 40.6 cm
(10 × 16 in)

Julian Waters
Alphabet, Silkscreen print.
36.2 × 47.5 cm (14¼ × 18¾ in)

Gunnlaugur SE Briem
Alphabet. Woodcut from a
plywood block. 63.5 × 45.1 cm
(25 × 17¾ in)

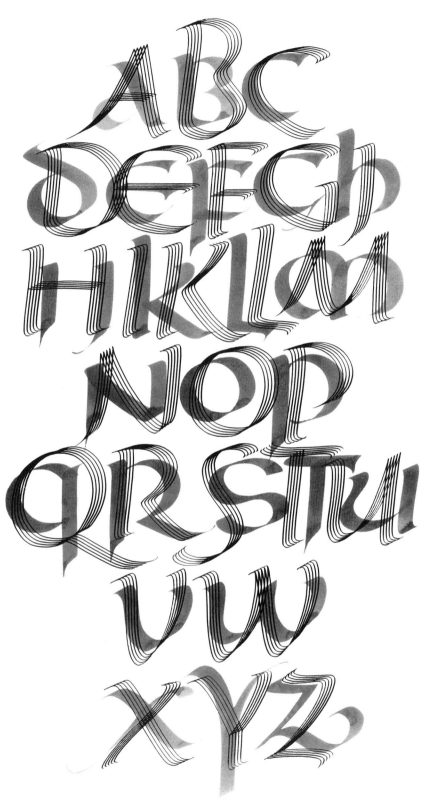

Peter Halliday
Alphabet designed for *60 Alphabets*
published by Thames and Hudson.
29.7 × 42.2 cm ($11\frac{3}{4}$ × $16\frac{5}{8}$ in)

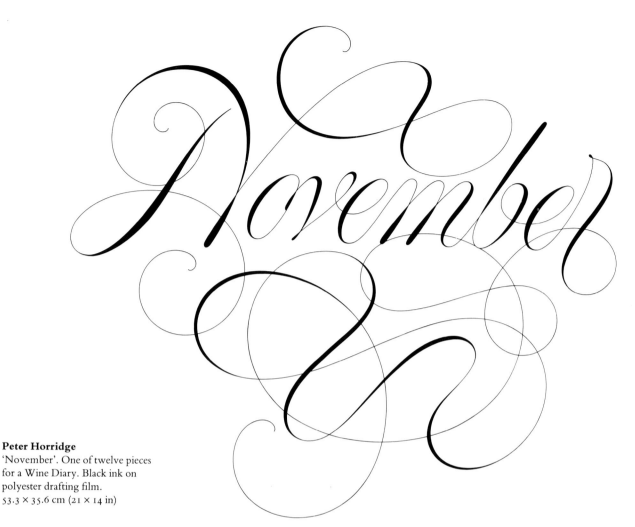

Peter Horridge
'November'. One of twelve pieces
for a Wine Diary. Black ink on
polyester drafting film.
53.3 × 35.6 cm (21 × 14 in)

John Woodcock
Certificate for OAGB. The logo is
brush drawn, and the remainder
pen written plus Baskerville type.
Printed litho in black and red on
Conqueror laid card. 29.5 × 21 cm
(11⅝ × 8¼ in)

OAGB
Osteopathic Association
of Great Britain

THIS IS TO CERTIFY THAT
Joanna E.M.Hine, DO, MRO
has satisfied the requirements of the
Association and has been duly elected to

FULL MEMBERSHIP

30 September 1984

PRESIDENT
MEMBERSHIP NUMBER: 8419

REGISTERED OFFICE: 1-4 SUFFOLK STREET, LONDON SW1Y 4HG

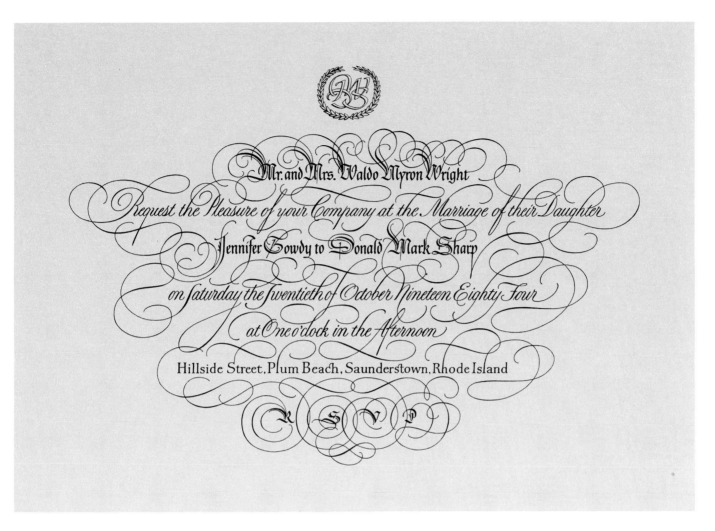

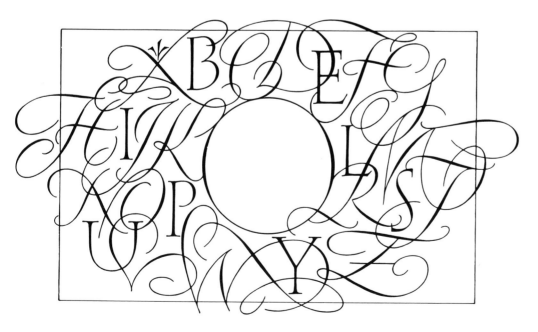

Raphael Boguslav
Invitation. Pen and ink, brush and ink. Printed size 13 × 18 cm ($5\frac{1}{8}$ × $7\frac{1}{8}$ in)

Pat Weisberg
'Alphabet'. Engraving on a crystal block for Steuben Glass. Written with a Mitchell 2/2 nib for the Roman letters and with the wash letters brush drawn on bond paper. Width of lettering 15 cm ($5\frac{3}{4}$ in)

GLENN BOOKS, *Inc.*
Our 50th Year

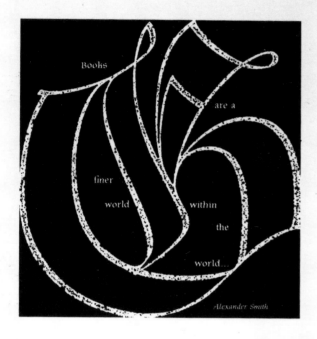

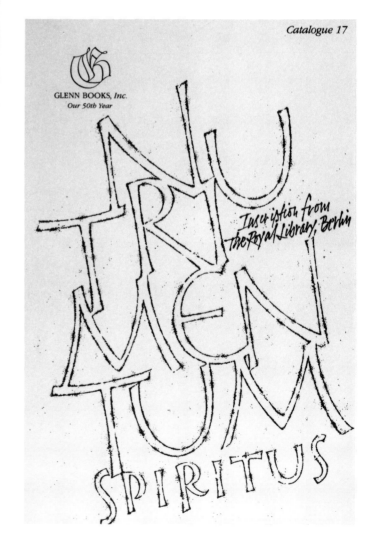

Rick Cusick
'Books are a finer world within the
world'. Design for Glenn Books
catalogue 19. 13 × 19.5 cm
(5⅛ × 7⅝ in)

'Nutrimentum Spiritus'. Design
for Glen Books catalogue 17.
13 × 19.5 cm (5⅛ × 7⅝ in)

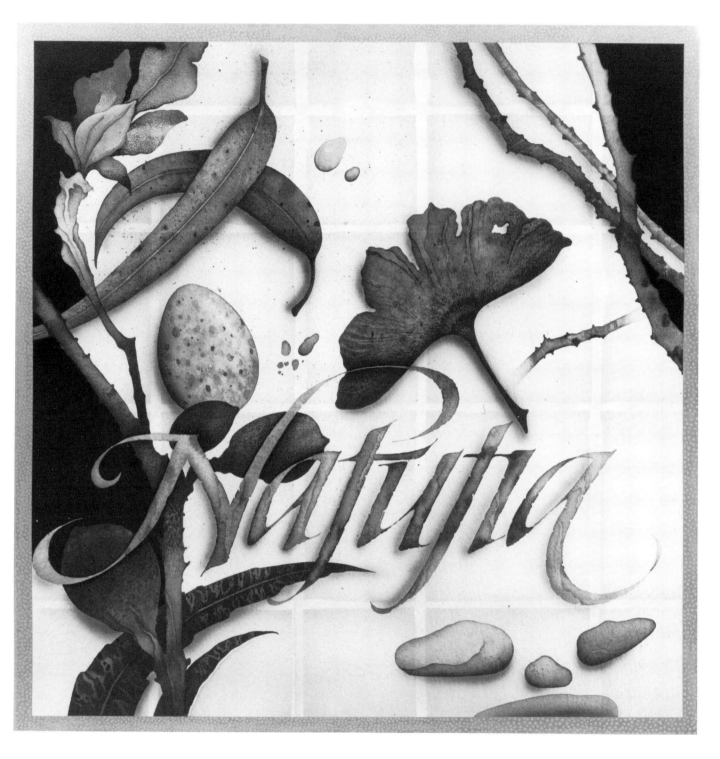

Kevin Elston
'Natura'. Watercolour with
calligraphy for a brochure cover.
35.6 × 35.6 cm (14 × 14 in)

Thine is the kingdom, power, and glory forever.

John Prestianni
Calligraphy for reproduction.
Metal pen on rough paper.

Banner for the *Journal of the Friends of Calligraphy*. 13 × 2 cm ($5\frac{1}{8} \times \frac{3}{4}$ in)

ALPHABET

Reader, Lover of Books, Lover of Heaven...
WILLIAM BLAKE

FINE PRINT

A REVIEW
for the ARTS
of the BOOK

John Prestianni
Design for a brochure. Actual size

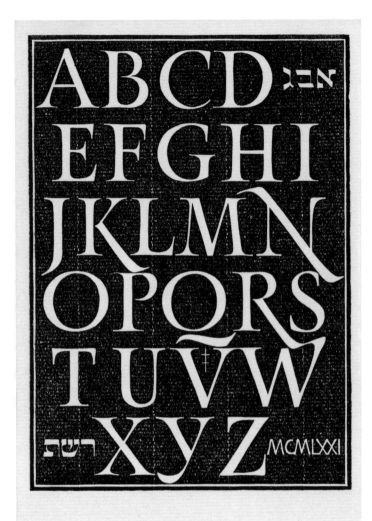

*Le plus grand chef-d'œuvre de la littérature
n'est jamais qu'un alphabet en désordre.*

Jean Cocteau

José Mendoza y Almeida
Christmas card. Lino hand-cut and printed on a hand printing proof press. 21 × 27 cm (8¼ × 10⅝ in)

Werner Schneider
Written with a Brause pen and black India ink on Ingres paper. 18.5 × 27.5 cm (7¼ × 10⅞ in)

John Woodcock
Map in the *Archaeological Atlas of the World*. Printed in brown with lettering in black and brown. Published by Thames and Hudson. Page size 24 × 17 cm (9¼ × 7¼ in)

Donald Jackson
Map of the world with place names mentioned in the text of *The Story of Writing*, French edition. Printed size 24.5 × 15.5 cm ($9\frac{5}{8}$ × 6 in)

Claude Mediavilla
Book cover. Written out in watercolour with a Brause steel pen on watercolour paper. Width of lettering 19 cm ($7\frac{1}{2}$ in)

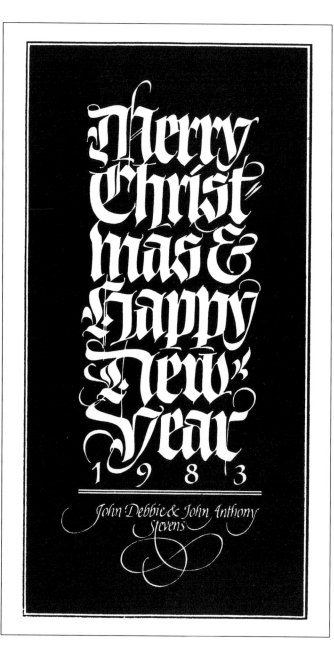

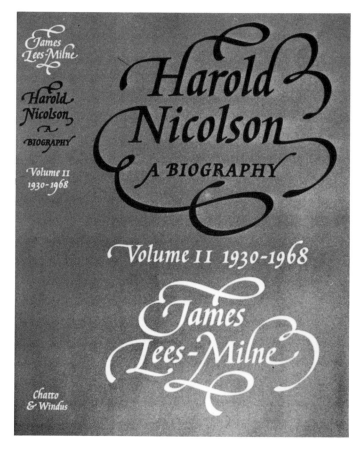

John Stevens
1983 Christmas card. Hand-cut silkscreen, written with reed and steel pen. 14 × 25.4 cm (5½ × 10 in)

Top, right
David Gatti
Lettering for a book jacket. Ink with pen and brush on Strathmore Bristol paper. 30.5 × 26.7 cm (12 × 10½ in)

John Woodcock
Book jacket. For Harold Nicolson's *Biography Vol II* published by Chatto and Windus. Printed in black and yellow on white paper. Page size 22 × 14.5 cm (8¾ × 5⅜ in)

Stephen Raw
Book jacket for *The Wine Dark
Sea* published by Carcanet. All
lettering written with a steel pen.
14 × 22.5 cm (5½ × 8⅞ in)

Stephen Raw
Book jacket for *Fires*, published by
Collins. Written with an automatic
pen on rough watercolour paper.
13.5 × 22 cm (5¼ × 8¾ in)

David Gatti
Lettering for a book cover. Ink
with pen and brush on Strathmore
Bristol paper. 30.5 × 5.1 cm
(12 × 2 in)

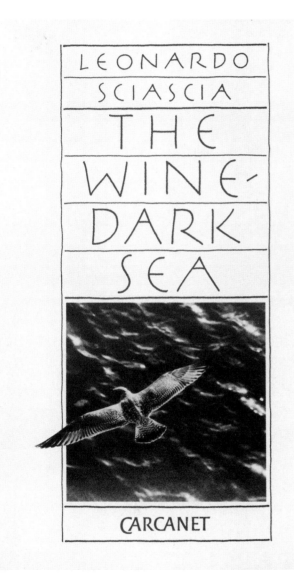

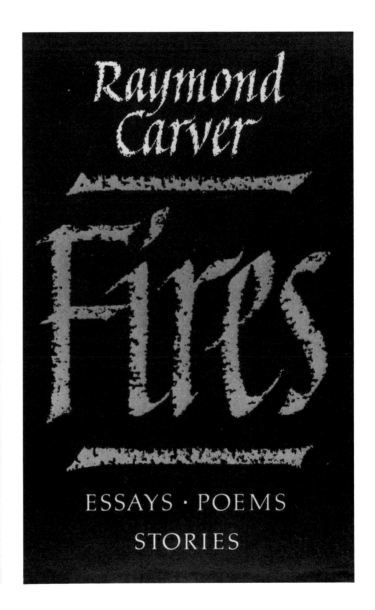

MASTERS OF GLASS

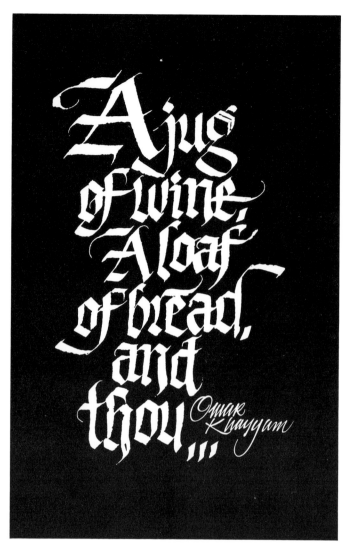

Peter Noth
Design for Hallmark Cards.
Written with a Brause pen.
18.4 × 22.2 cm (7¼ × 8¾ in)

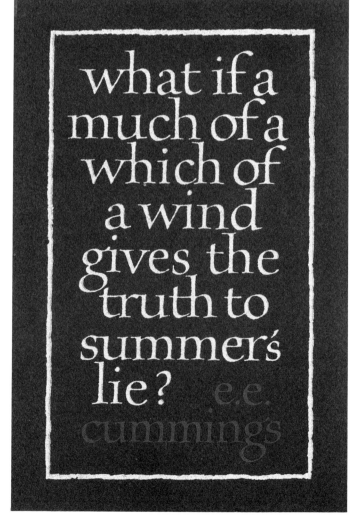

Jerry Kelly
Christmas card. Quotation fronm
E E Cummings. Silver and blue
pen lettering on dark blue paper.
10.8 × 15.9 cm (4¼ × 6¼ in)
© 1944 by E E Cummings: 1972
by E E Cummings Trust

88

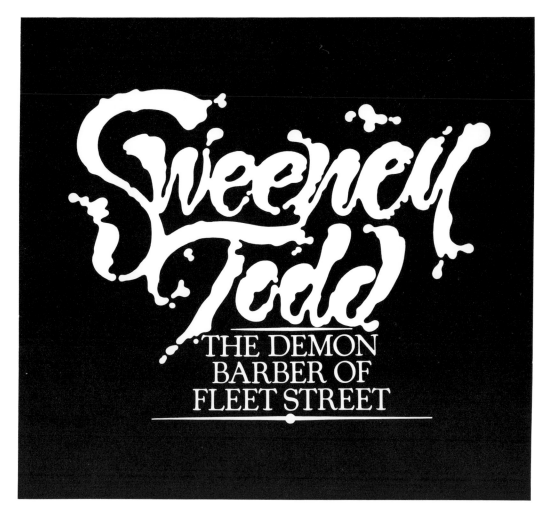

Peter Horridge
'Sweeney Todd'. The main logo
for a set of introductory titles for
television. Black ink on polyester
drafting film. 38.1 × 27.9 cm
(15 × 11 in)

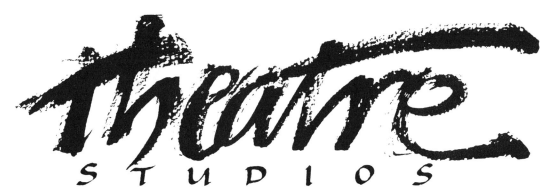

Lilly Lee
Letterheading for a company.

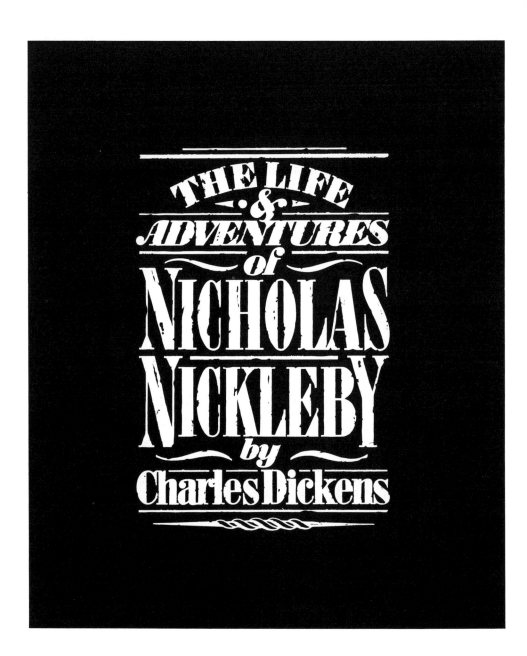

Peter Horridge
'Nicholas Nickleby'. The main
title in a set of introductory titles
for television. Black ink on
polyester drafting film.
43.2 × 27.9 cm (17 × 11 in)

Annie Cicale
Logo design for condominiums in
Whitefish, Montana. To be
reproduced at 60% of the original
size. Written with Powell pens in
Winsor and Newton ink on Arches
140 CP and retouched.

Jovica Veljović
'Vukova Azbuka'. The title of a book by Dusan Radovic. Written in Cyrilic with a metal pen and reed on paper. 15 × 22 cm ($5\frac{7}{8} \times 8\frac{5}{8}$ in)

Martin Wilke
Book jacket design for T S Eliot's *Old Possums Katzen Buch*.

Bottom, left
David Gatti
Lettering for a book jacket. Ink with pen and brush on illustration board. 22.9 × 27.9 cm (9 × 11 in)

Bottom, right
Robert Boyajian
Lettering for the cover of a music book. Pen drawn.

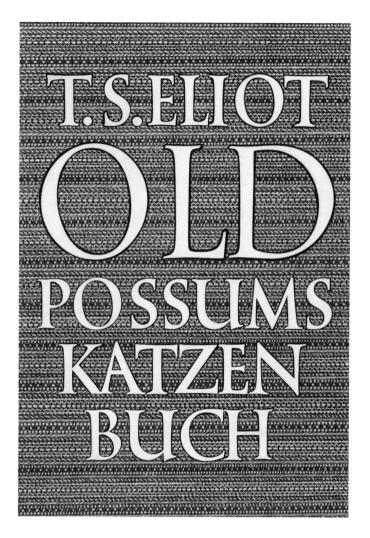

Heather Child
Five bookplates. Reproduced actual size

Donald Jackson
Bookplate for Hans Erling
Langkilde. 10×7 cm ($4 \times 2\frac{3}{4}$ in)

Robert Williams
Bookplate for Northwestern
University. Printed in grey ink.
Courtesy of Northwestern
University Library. 5.1×6.2 cm
($2 \times 2\frac{1}{2}$ in)

Gerald Fleuss
Business card. Pen drawn.
Reversed artwork. 6.5×9 cm
($2\frac{1}{2} \times 3\frac{1}{2}$ in)

John Woodcock
Bookplate for the Taylor
Institution Library, Oxford. The
lettering was written with a metal
pen, adapted with a brush, and
then the details varied on the
enlarged photo-print which
formed the artwork for
reproduction. 10×7.5 cm
(4×3 in)

Right and below, left
Bonnie Spiegel
Stationery for the Portland
Symphony Orchestra. Envelope
11.4 × 14.6 cm (4½ × 5¾ in)

Kevin Horvath
'A Dancing Butterfly'. Quotation
from Kiyo. Artwork for
reproduction in the Taplinger
calendar. Bowsma pen on vellum
paper. 11.4 × 15.3 cm (4½ × 6 in)

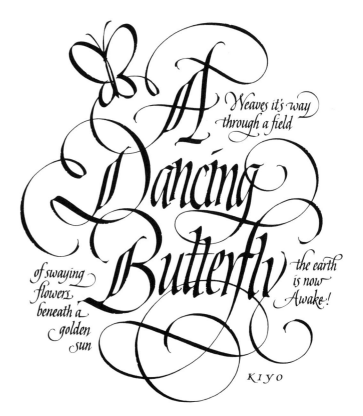

Patricia Buttice
'The Light Shines'. Christmas card. Printed on heavy stock, blue with white letters. Calligraphy executed with Speedball C and Mitchell Rexel pens on bond paper. 23.5 × 10.2 cm (9¼ × 4 in)

Guy Giunta
Logo for Dinnerware Designs. Written actual size with a ruling pen on a writing tablet.

Gerald Fleuss
Cognac label for Eldridge Pope and Co. Hand printed by Will Carter, Rampant Lion Press, on Barcham Green's Sandwich handmade paper. Printed size 12.7 × 11.4 cm (5 × 4½ in)

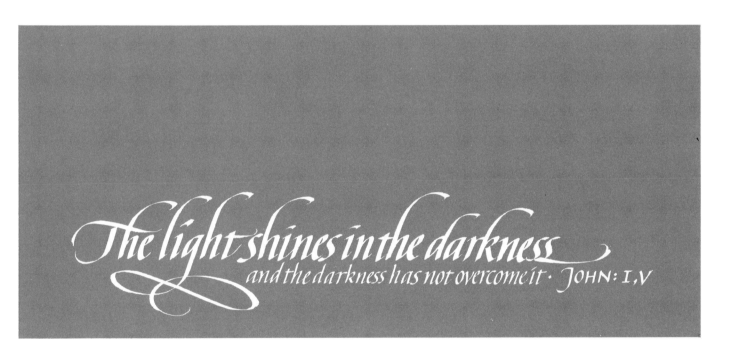

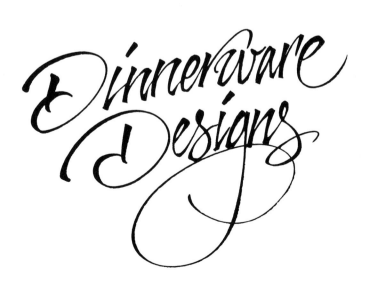

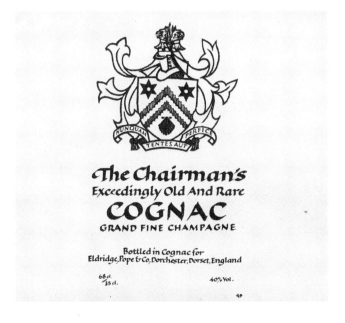

Sam Somerville
Letterheading. Offset litho from a hand-written original.

Heather Child
Change of address card. Original artwork was reversed for reproduction

Donald Jackson
Logo design for garment and fabric labels. Width of lettering 6 cm (2⅜ in)

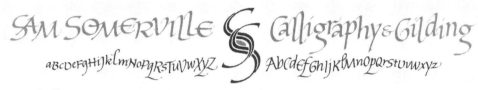

229 Washington Street · Brookline Village · 0 2 1 4 6

Ieuan Rees
Letterheading for Mumbles
Gallery. Pen drawn. Large letters
1.3 cm ($\frac{1}{2}$ in) high

Raphael Boguslav
Letterheading.

Colleen
Diana's logo design. Drawn with a
Brause nib and Sumi ink. Diameter
8.9 cm ($3\frac{1}{2}$ in)

Below, left
Alan Blackman
Personal greeting. Brush written in
black ink for colour Xerox
reproduction. 27.9 × 21.6 cm
(11 × 8½ in)

Centre and bottom left
Peter Halliday
Logos for building sites. Design to
be enlarged for sign painters and
reduced for use on publicity
material. Originals written with
automatic pen size no. 4.

Below, right
Gaynor Goffe
'Fireworks'. Artwork for the
Craftsmen Potters Association
Exhibition of Members' work,
1984. Pen lettered. 50.8 × 27.9 cm
(20 × 11 in)

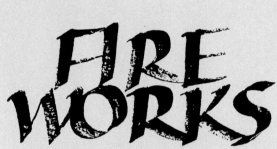

FIRE WORKS

25/29 SEPTEMBER 1984

AN EXHIBITION OF WORK
DONATED BY FULL MEMBERS OF THE
CRAFTSMEN POTTERS ASSOCIATION
TO CELEBRATE DAVID CANTER'S
GREAT CONTRIBUTION TO THE CRAFTS

PROCEEDS TO
THE DAVID CANTER FUND

THE CRAFTSMEN POTTERS SHOP
WILLIAM BLAKE HOUSE · 7 MARSHALL ST ·
LONDON W1V 1FD · TEL · 01 · 437 · 7605
Monday · Friday 10/5·30 pm · Saturday 10·30/5 pm

INVITATION TO THE

PRIVATE VIEW

MONDAY 24 SEPTEMBER 6/8 PM

W · I · N · E

Personality & Morality

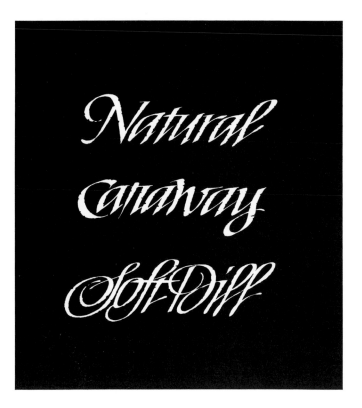

Tom Carnase
'The Cooper Union'. Logo for the
Art Institute. Pen drawn letters.
Width of lettering 14 cm (5½ in)

Claude Dieterich
Monogram executed with a brush.
Width of lettering 5.5 cm (2¼ in)

Top
Kevin Horvath
Logo for the Nottingham Court
housing subdivision. To be
reproduced in burgundy on grey.
Written with a Bowsma pen.

Above, left
Claude Dietrich
Logo for a folk singers group.
Executed with a brush. Width of
lettering 7 cm (2¾ in)

Above
Annie Cicale
Logo for a dress shop. Powell pen,
Winsor and Newton ink on
clearprint 1020 paper. Width of
lettering 15.3 cm (6 in)

Tom Nikosey
Album cover design. Acrylic
painting. 45.7 × 61 cm (18 × 24 in)

Claude Dieterich
Logo for a restaurant. Width of
lettering 7.5 cm (3 in)

Mike Manoogian
Rick Springfield.

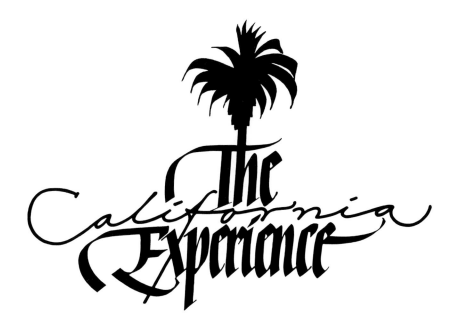

Ken Jackson
Logo for the International Assembly of Letter Artists. To be used in various sizes. Width of the letters 22 cm (8$\frac{5}{8}$ in)

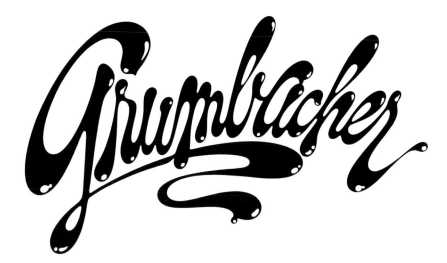

Tom Carnase
Grumbacher corporate logo for art products. Width of letters 14 cm (5$\frac{1}{2}$ in)

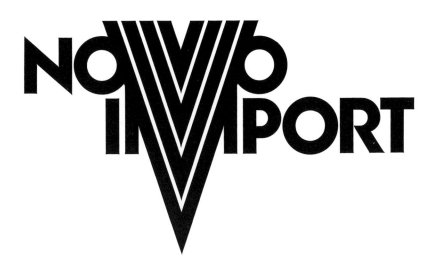

Claude Dieterich
Logo for an importer. Width 9 cm (3$\frac{1}{2}$ in)

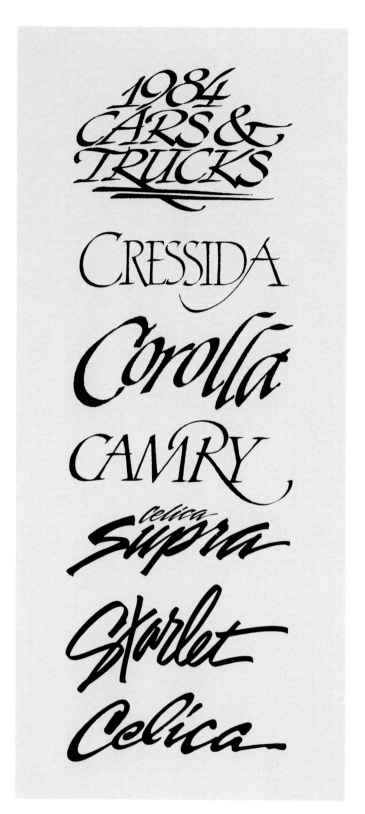

Mike Manoogian
1984 Cars and Trucks.

David Quay
Q & G monograms. Finished artwork by Paul Gray. These logos are used on a range of stationery. The artwork was drawn with a Rotring rapidograph and the airbrushing with a De Vilbis aerograph.

David Quay
Ad-Hoc logo. Finished artwork by Paul Gray. Ad-Hoc is the title of an in-house magazine sent out to advertising agencies. The logo utilises elements in plate making and colour separation. The artwork was drawn with a Rotring Rapidograph on to plastic drawfilm, the letter 'C' was brush drawn, and the colour gradations computer generated. 35 cm (13¾ in) across

Pattie Lamb
Lettering for the corporate stationery of a photography company. The original lettering drawn with a Rotring Art Pen, enlarged and prepared for reproduction.

105

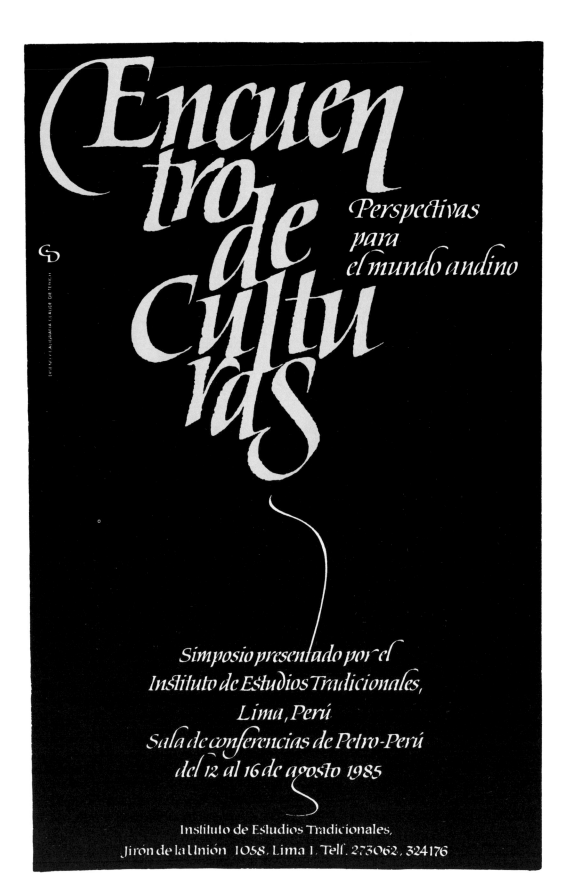

Claude Dieterich
Poster. Printed by offset
lithography. 48.3 × 30.5 cm
(19 × 12 in)

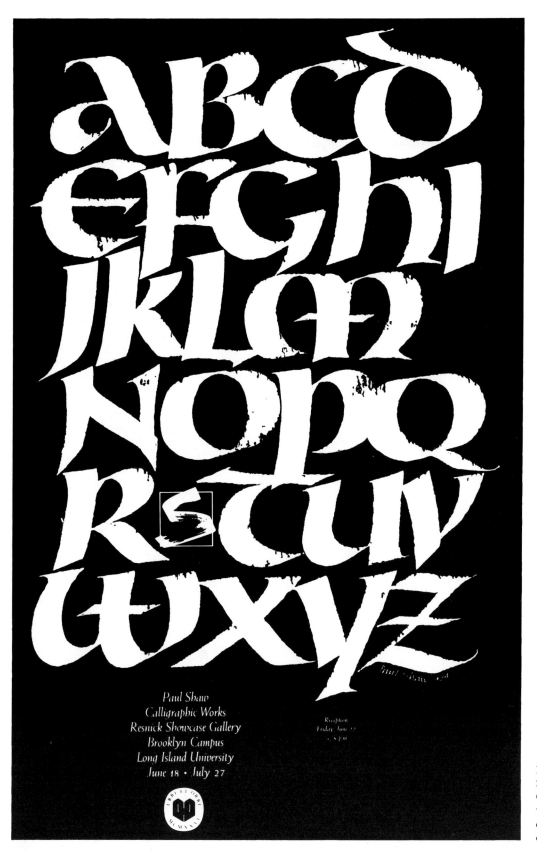

Paul Shaw
Solo exhibition announcement.
Coit poster pens on Arches
watercolour paper and printed
offset onto coated paper white
on black.

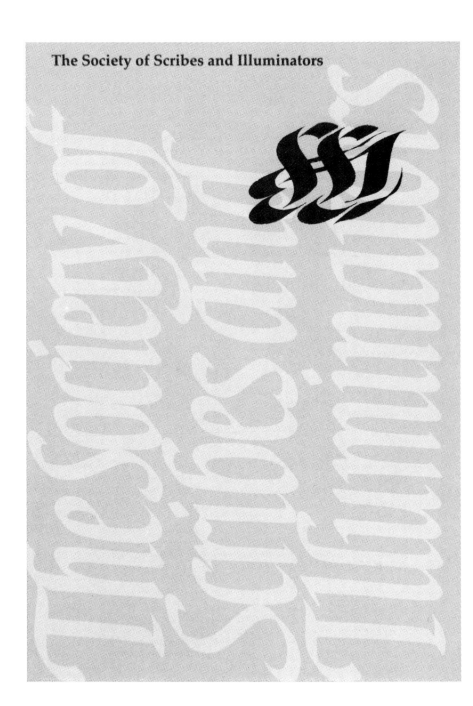

The Society of Scribes and Illuminators

John Woodcock
Design for a brochure for the
Society of Scribes and Illuminators.
The large letters written with a
reed pen in black, then reversed
out of a 10% tint background.
Small letters typeset in Palatino
Bold. 15 × 21 cm ($5\frac{3}{4}$ × $8\frac{1}{4}$ in)

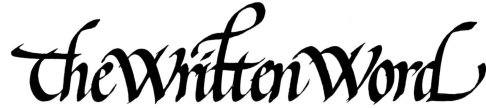

The Written Word
A SPECIAL REPORT ON THE ART, TECHNIQUE
AND IMPLEMENTS OF HANDWRITING

Donald Jackson
Heading for a two-page report in
The Times, 3 December 1981.
Written with a large turkey quill.
Width of lettering 22 cm ($8\frac{5}{8}$ in)

International
exhibition
of calligraphy

Living
Letters

Alþjóðleg
sýning á
skrautskrift

College of
Art and Crafts,
Iceland

Lifandi
letur

Easter 82

Myndlista-og
handíðaskóli
Íslands &
Gunnlaugur SE Briem

Páskar 82

Gunnlaugur SE Briem
Exhibition catalogue cover. Pen
lettering. 29.5 × 21 cm
($11\frac{5}{8} \times 8\frac{1}{4}$ in)

John Stevens
Tenth anniversary logo for the
Society of Scribes, New York.
26 × 25.4 cm (10¼ × 10 in)

Alice
The names of the twenty founding
members of the Society of Scribes
in New York City. The heading
was lettered with a reed pen in
turquoise watercolour, and the
members' names with a turkey
quill in Waterman's Aztec Brown
ink on handmade paper.
17.8 × 58.4 cm (7 × 23 in)

Pattie Lamb
Poster design for The Society of
Scribes and Illuminators' travelling
exhibition. Original lettering in
ink with swan and goose quills and
automatic pens. Two-colour
design prepared as a visual using a
daylight dry transfer system.
42×29.7 cm ($16\frac{1}{2} \times 11\frac{3}{4}$ in)

Ken Jackson
'The Poetry of the Pen'. Exhibition poster.

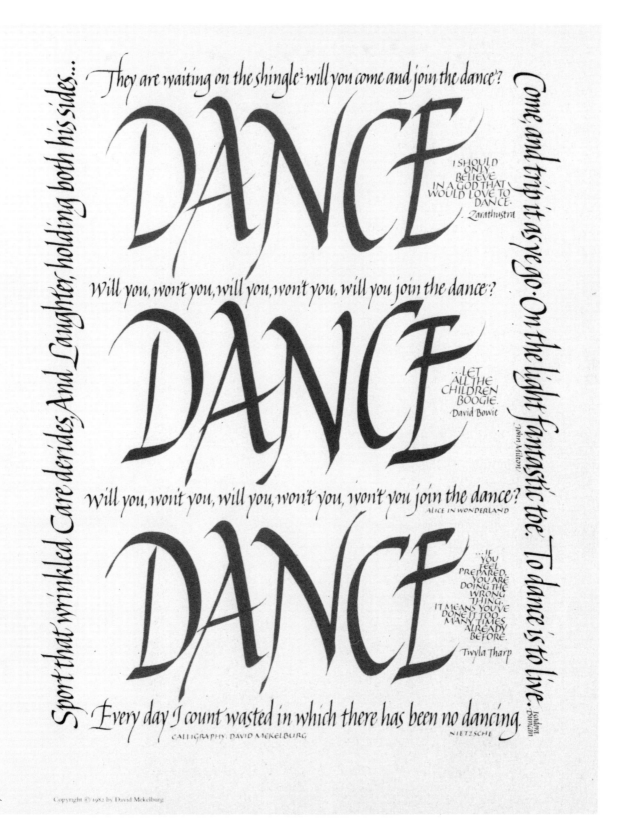

David Mekelburg
Poster with various quotations
about dance. Offset lithography in
green, dark red and black.
27.9 × 35.6 cm (11 × 14 in)

113

Tom Nikosey
*The Directory of Creative Talent
International.* Acrylic painting.
45.7 × 61 cm (18 × 24 in)

Alice
Exhibition poster. Original
executed in Coit pen, Stephens
violet fountain pen ink, 3-A
automatic and speedball C-o nib
with Waterman's Aztec Brown
ink, on recycled paper.
38.1 × 33 cm (15 × 13 in)

Gunnlaugur SE Briem
'The Apple Man', logo. To be used
in various sizes.

Gaynor Goffe
'Christmas Celebration' invitation
for the Craftsmen Potters
Association, 1984. Pen lettered.
22.9 × 15.3 cm (9 × 6 in)

Lorenzo Homar
Seriograph for lettering, posters
and prints. 50.8 × 35.6 cm
(20 × 14 in)

Emily Brown Shields
'Trust in the Lord'. Written with
an automatic pen and Mitchell nibs
on watercolour and bond paper.
14.6 × 14.9 cm (5¾ × 5⅞ in)

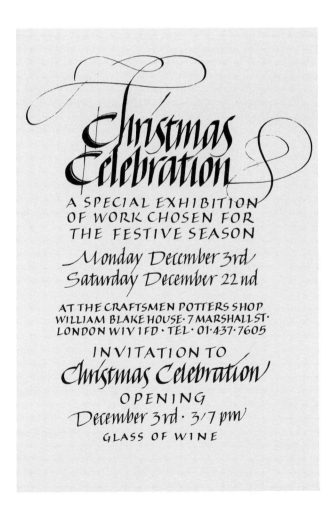

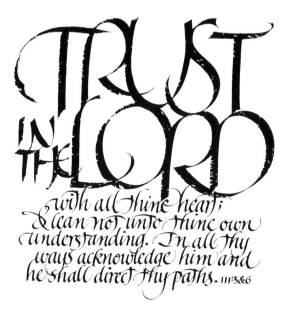

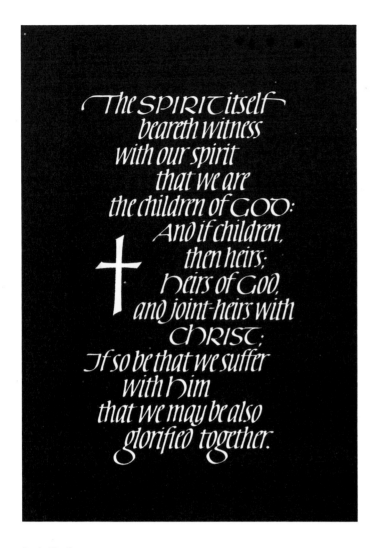

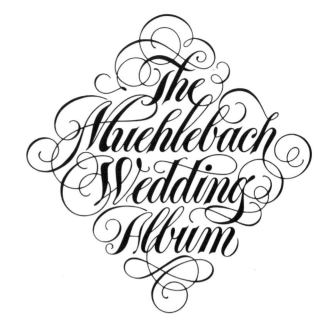

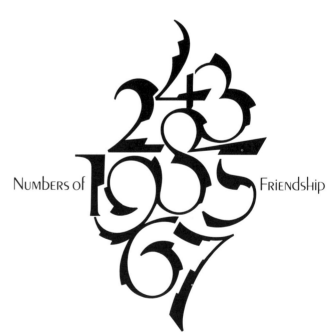

Susie Taylor
Memorial card. Calligraphy for reproduction. Original size
10.2 × 15.3 cm (4 × 6 in)

Guy Giunta
Brochure cover for the Radisson Muehlebach Hotel. Drawn with a pencil and rendered with a brush. Reproduced in gold foil.
18 × 18 cm (7 × 7 in)

Lars Olof Laurentii
'Numbers of Friendship'. A symbol appliqued on to a Christmas card. 24 × 15 cm
(9½ × 5⅞ in)

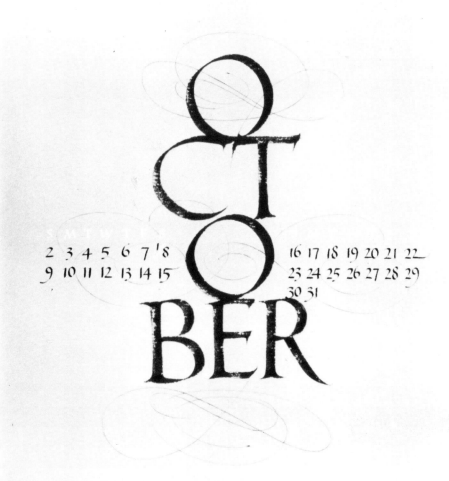

OCTOBER

S M T W T F S

2 3 4 5 6 7 '8
9 10 11 12 13 14 15

16 17 18 19 20 21 22
23 24 25 26 27 28 29
30 31

Robert Boyajian
'Wall calendar'. Brush, Roma
Fabriano paper, Winsor and
Newton gouache. 36.8 × 40 cm
($14\frac{1}{2} \times 15\frac{3}{4}$ in)

WE wish you a Merry Christmas
we WISH you a Merry Christmas
we wish YOU a Merry Christmas
we wish you A Merry Christmas
we wish you a MERRY Christmas
we wish you a Merry CHRISTMAS
and a Happy New Year

John Smith
Christmas card. Offset litho in two
colours. 14 × 9 cm ($5\frac{1}{2} \times 3\frac{1}{2}$ in)

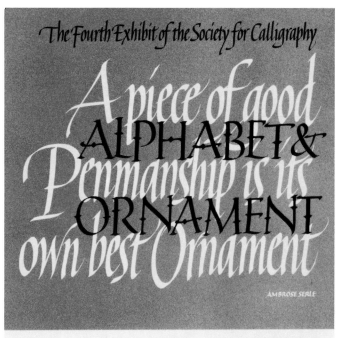

David Mekelburg
Exhibition poster for the Society
for Calligraphy. Photographic
silkscreen on white paper in black
and vermilion. 50.8 × 66 cm
(20 × 26 in)

Karlgeorg Hoefer
'Our Father'. Written with a
pointed brush in his own version of
Fraktur (German Gothic).
59 × 42 cm (23¼ × 16½ in)

Robert Williams
Announcement for the Newberry
Library. Printed in green-blue ink.
Courtesy of the Newberry
Library. 10.8 × 15.3 cm (4¼ × 6 in)

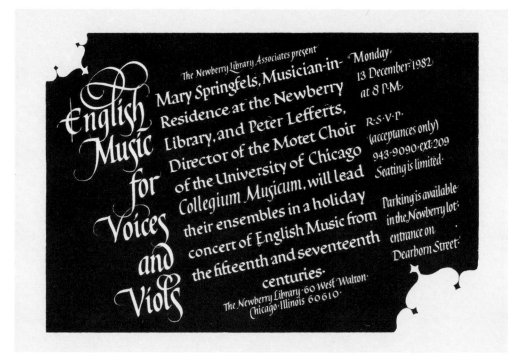

Paul Shaw
Greeting card. Pen drawn, with
large red letters and typography in
orange on white paper. 23 × 10 cm
(9 × 4 in)

Villu Toots
Two pieces written in gouache
with a Brause auto-pen.
23.9 × 19 cm (9 × 7½ in)

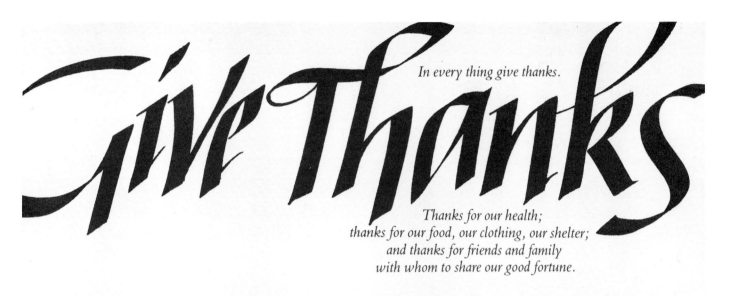

In every thing give thanks.

Thanks for our health;
thanks for our food, our clothing, our shelter;
and thanks for friends and family
with whom to share our good fortune.

BEST WISHES FOR PEACE AND PROSPERITY IN 1984

Lugupeetud juubilar !
ENSV Kultuuriministeeriumi juhtkond, parteialg-
organisatsioon, ametühing ning arvukad kolleegid
ühinevad juubeliõnnesoovis Sulle, kes Sa kaua-
aegse kultuuritöötajana meie ridades oled
võidelnud ja ausa ning kindlameelse
kommunistina vabariigi kunstielu juhtinud.
Sulle, kelle päevpäevase töö tulemusel
kerkivad monumendid, võrsuvad uued talendid,
sünnivad muuseumid, arenevad kultuurisidemed.

Kunst
on ikka kapriisne olnud.
Ta areneb üha omasoodu, nähtamatuid siseteid pidi.
Suur oskus on teda mõista, veel suurem-teda
suunata. Sina, kallis juubilar, oled alati
osanud temaga heal jalal seista-kaitsnud seda,
mis temas kaunis, kritiseerinud, mis võlts.
Oled ikka säilitanud erksa loomingulise vaimu
töövõimu, eluvõimu. Jätkugu seda veel kauaks
ja küllaga !

Villu Toots
Written in gouache with a Brause
auto-pen. 23 × 19 cm (9 × 7½ in)

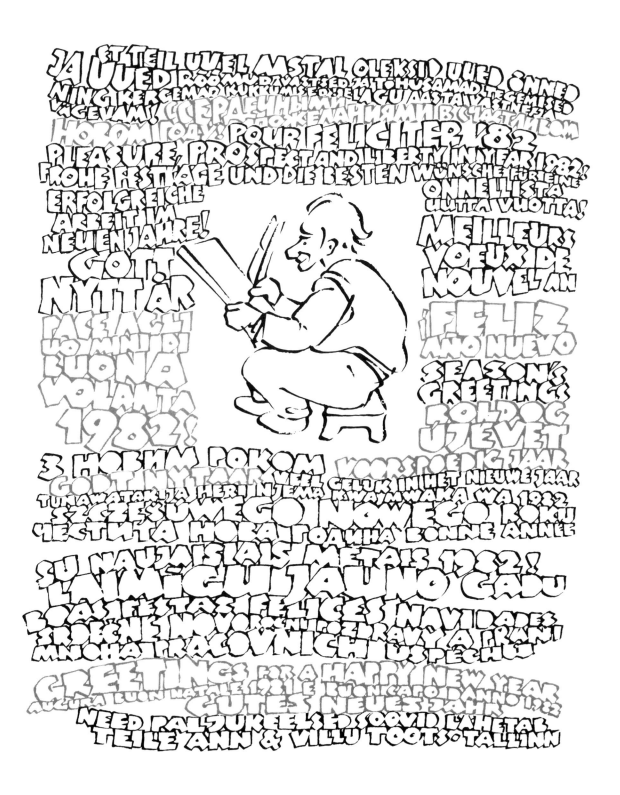

Villu Toots
Limited edition greetings card
for 1982.

OMAR CHAJJÁM

Preložil Pavol Horov

Podivne ubieha tá karavána žitia :
veselý okamih je sen, čo poteší ťa.
Hej, čašník, netráp sa budúcou našou biedou,
nalievaj do čaše, čoskoro začne svitať.

Lubomír Krátky
Double page spread from the book
Kaligrafie published by Slovensky
Spisovatel, Bratislava, 1984.
Printed offset. The originals were
written on handmade paper with a
flat-edged pen.
40 × 55 cm (15¾ × 21¾ in)

V osídlach osudu
sme ako vtáci holí,
zmámené večnosťou srdce nás
strašne bolí.

Blúdime po svete,
čo pre nás strechy nemá:
príchody, odchody
vždy proti vlastnej vôli.

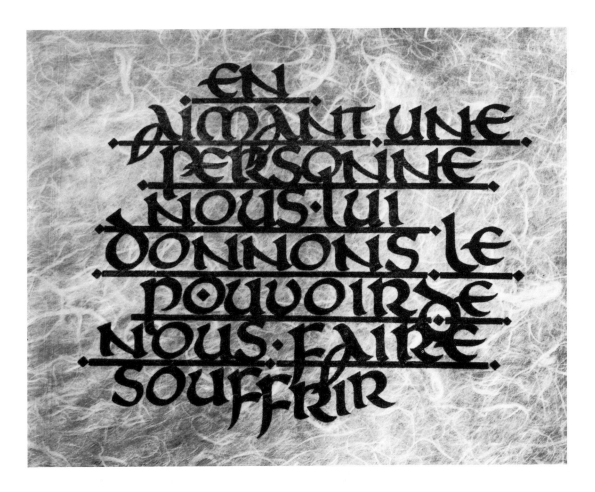

Marion Andrews
'En aimant'. Lithograph. Drawn in
reverse with lithographic pencil on
a lithostone and printed on
Japanese paper. 50 × 65 cm
($19\frac{3}{4} \times 25\frac{5}{8}$ in)

Hans Joachim Burgert
Circular lettering. From *Ludus
Scribendi* (1982).

Facing page
Gunnlaugur SE Briem
Silkscreen print of runes. It shows
3 stages of the Futhark alphabet:
pre-Viking, Viking and Medieval.
In the middle is a Viking ornament
in the Urnes style. 43.2 × 30.5 cm
(17 × 12 in)

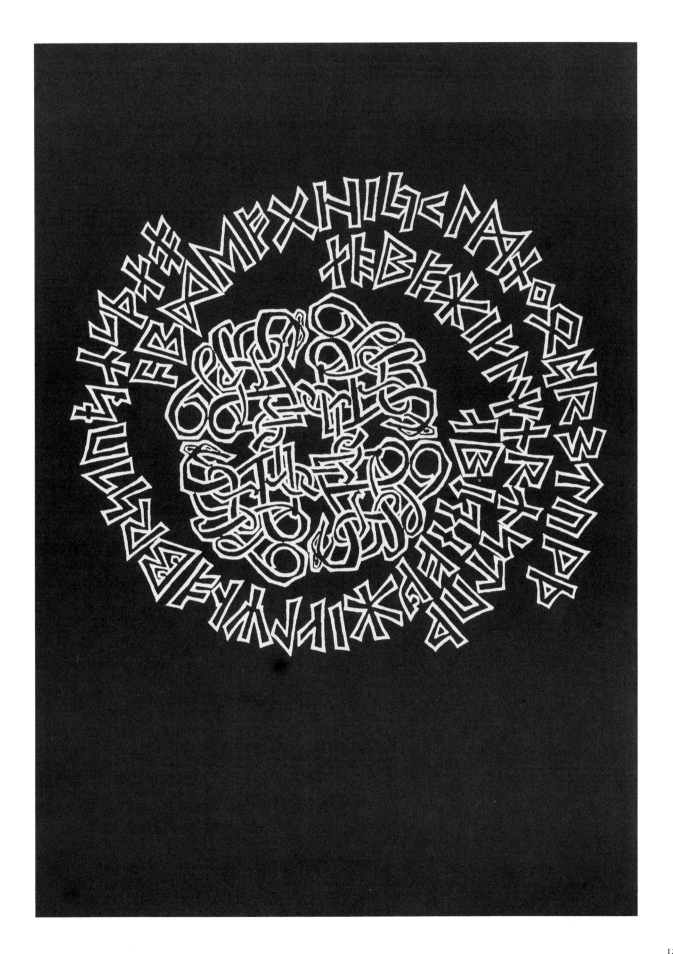

Sidney Day
Design for a bone china plate.
Diameter 28 cm (11 in)

Facing page
Hans Joachim Burgert
'Der prediger Salomo'. Printed on
handmade paper. 10 × 28 cm
(4 × 11 in)

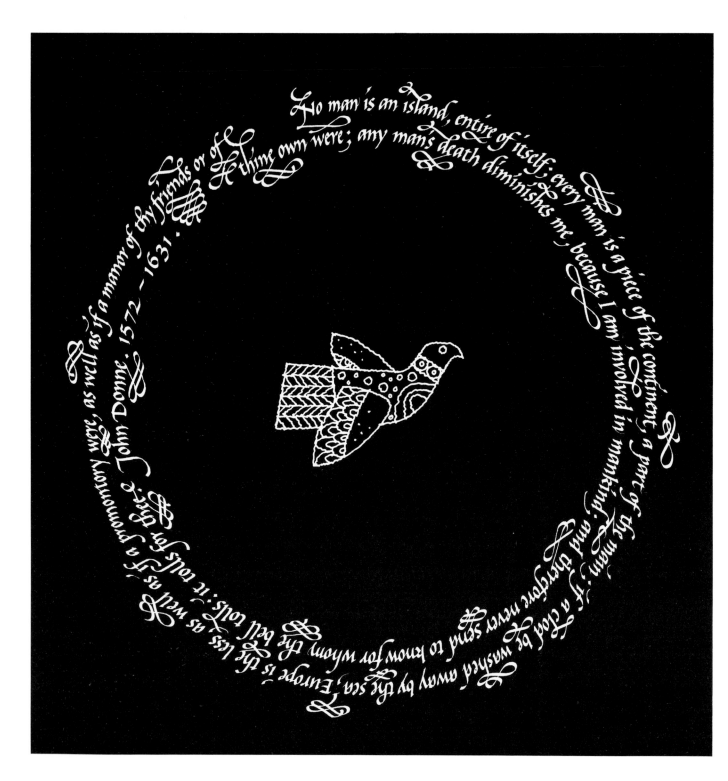

So geh hin und iß dein Brot
mit Freuden, trink deinen
Wein mit gutem Mut, denn
dein Werk gefällt Gott.
Laß deine Kleider immer weiß

sein und laß deinem Haupt
Salbe nicht mangeln. Brauche
das Leben mit deinem Weibe,
das du liebhast, solange du das
eitle Leben hast, das dir Gott
unter der Sonne gegeben
hat, solange dein eitel Leben

währt, denn das ist dein
Teil im Leben und in deiner
Arbeit, die gut ist unter der
Sonne. Alles, was dir vor
Händen kommt zu tun, das

tue frisch, denn bei den Toten,
dahin du fährst, ist weder Werk,
Kunst, Vernunft noch Weisheit.
Ich wandte mich
und sah, wie es unter der
Sonne zugeht, daß zum
Laufen nicht hilft schnell sein

52 53

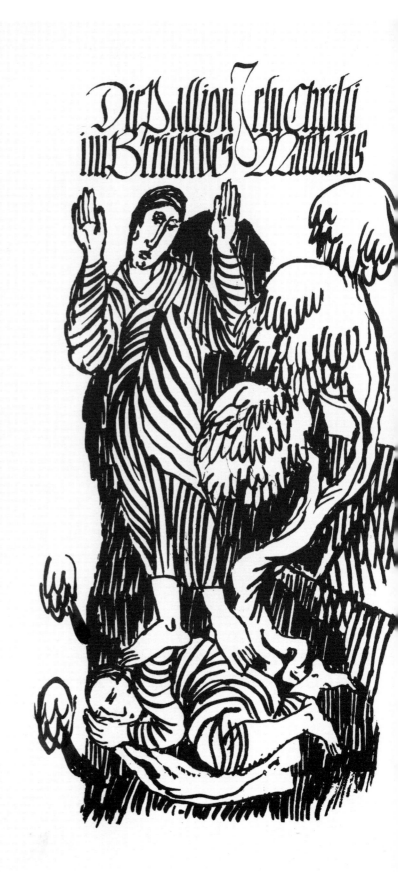

Hans Joachim Burgert
Double page spread from *Die Kleine Passion*, published by Burgert Handpresse, Berlin, on handmade paper. Page size 30.5 × 21.5 cm (12 × 8½ in)

Jesus aber stund vor dem Land
pfleger. Und der Landpfleger
fraget ihn und sprach: Bist du der
Juden König? Jesus aber sprach
zu ihm: Du sagts. Und da er
verklagt ward von den Hohen
priestern und Ältesten antwor-
tet er nichts. Da sprach Pila-
tus zu ihm: Hörst du nicht wie
hart sie dich verklagen? Und
er antwortet ihm nicht auf
ein Wort, also dass sich auch der
Landpfleger sehr verwunderte.
Auf das Fest aber der Landpfle-
ger die Gewohnheit dem Volk
einen Gefangenen los zuge-
ben, welchen sie wollten. Er hatte
aber zu der Zeit einen Gefangenen

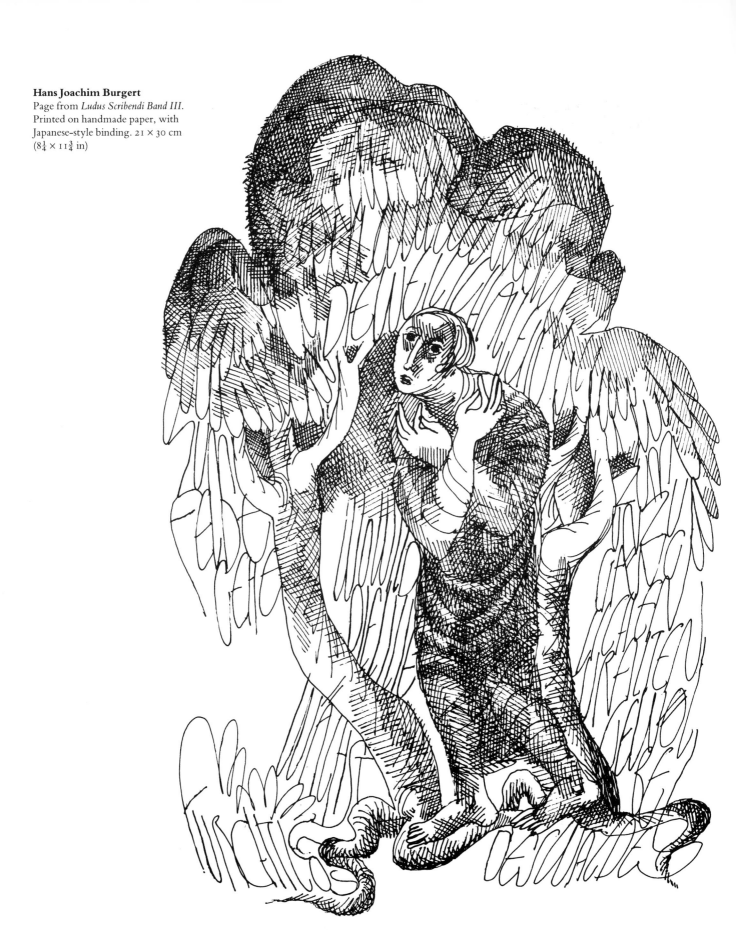

Hans Joachim Burgert
Page from *Ludus Scribendi Band III*.
Printed on handmade paper, with
Japanese-style binding. 21 × 30 cm
(8¼ × 11¾ in)

Inscriptional and three-dimensional lettering

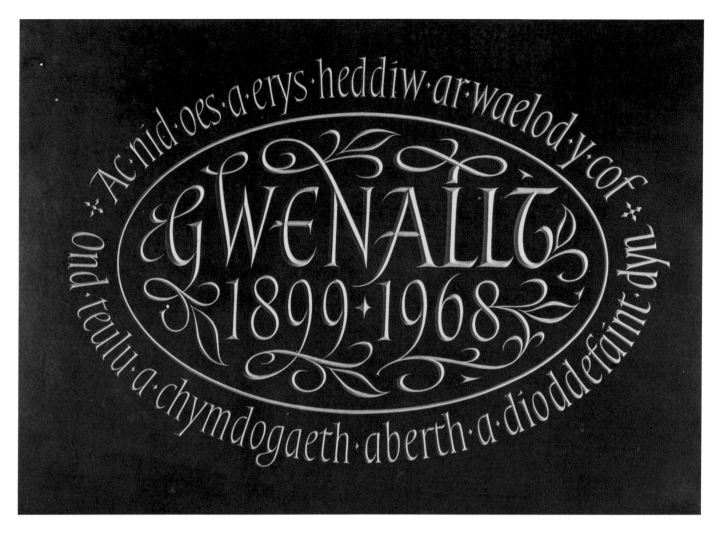

Ieuan Rees
'Gwenallt'. Welsh slate. 76.2 cm
(30 in) long.

'The Calligraphy Connection'.
Silkscreen replica for a design for a
carved inscription in Welsh slate
for St John's University,
Collegeville, Minnesota. Diameter
76.2 cm (30 in)

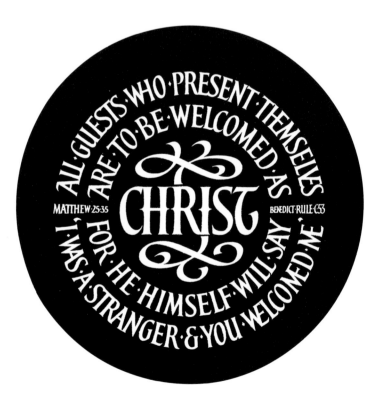

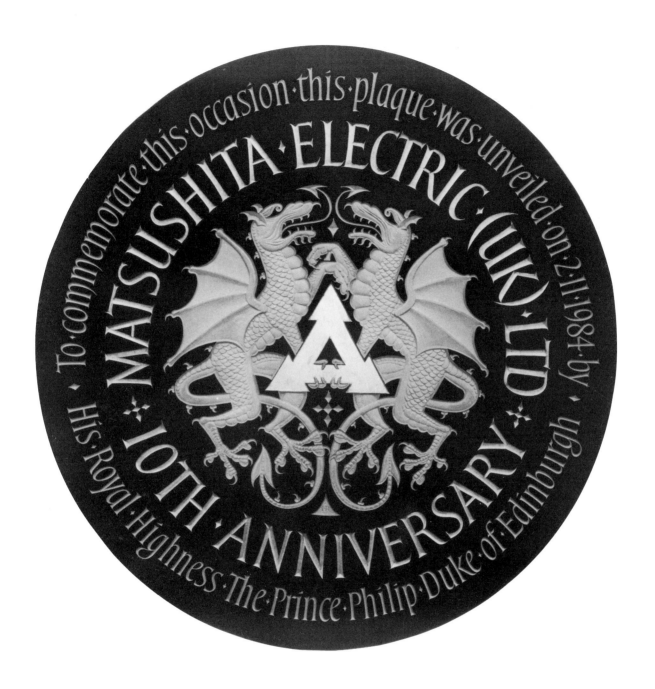

Ieuan Rees
Plaque to commemorate
Matsushita's tenth anniversary.
The Italic lettering and the dragons
in natural grey, with the capitals
and symbols gilded. Welsh blue-
black slate. Diameter 76.2 cm
(30 in)

133

David Kindersley and Lida Lopes Cardozo
Plaque for Peterhouse College, Cambridge. Green slate, letters cut and painted. 50.8 × 108 cm (20 × 43½ in)

John Skelton and Jack Trowbridge
Memorial to Sir Winston Churchill in St Pauls Cathedral, London. One-piece bronze fret set in black marble. 100 × 53.3 cm (39 × 21 in)

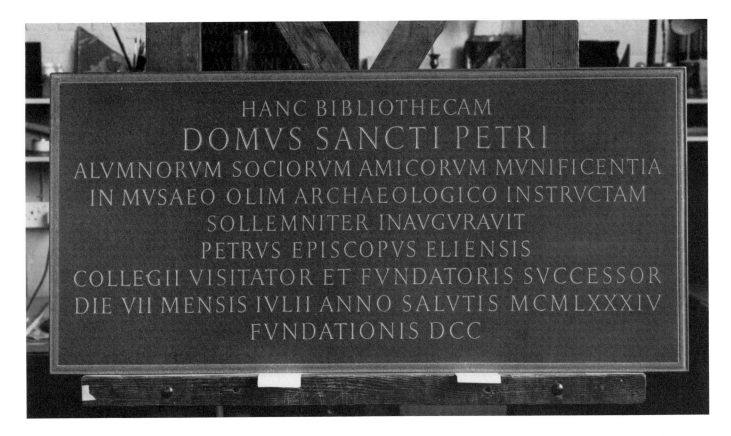

HANC BIBLIOTHECAM
DOMVS SANCTI PETRI
ALVMNORVM SOCIORVM AMICORVM MVNIFICENTIA
IN MVSAEO OLIM ARCHAEOLOGICO INSTRVCTAM
SOLLEMNITER INAVGVRAVIT
PETRVS EPISCOPVS ELIENSIS
COLLEGII VISITATOR ET FVNDATORIS SVCCESSOR
DIE VII MENSIS IVLII ANNO SALVTIS MCMLXXXIV
FVNDATIONIS DCC

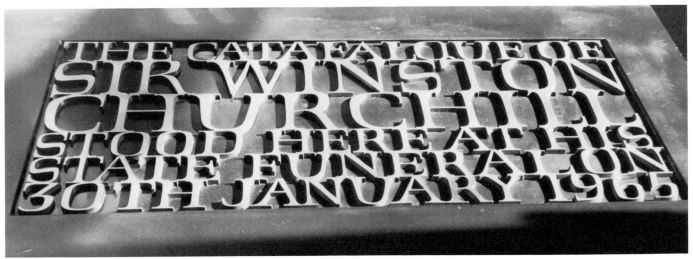

THE CATAFALQUE OF
SIR WINSTON
CHURCHILL
STOOD HERE AT HIS
STATE FUNERAL ON
30TH JANUARY 1965

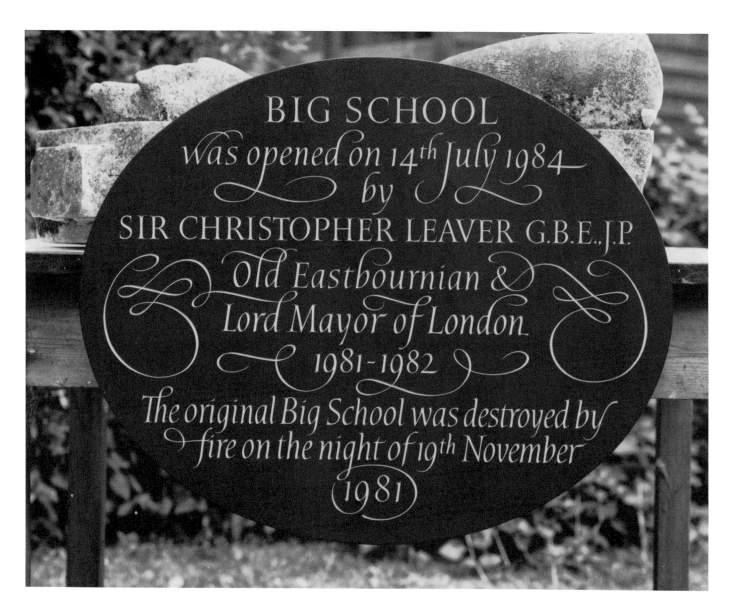

David Kindersley and Lida Lopes Cardozo
Big School. Slate. Letters cut and painted off-white. 50.8 × 63.5 cm (20 × 25 in)

Field Marshal
VISCOUNT
MONTGOMERY
OF ALAMEIN KG
GCB·DSO
1942~44 Commander 8th Army
North Africa & Italy·1944-45 CinC 21st
Army Group North West Europe
1946~1948 Chief of The Imperial
General Staff · 1951~1958
Deputy Supreme Commander
Allied Powers Europe

1887 1976

John Skelton
Viscount Montgomery. One of ten
panels commemorating the great
Commanders of World War II in
St Pauls Cathedral, London.
Nabresina marble. 102 × 76.2 cm
(40 × 30 in)

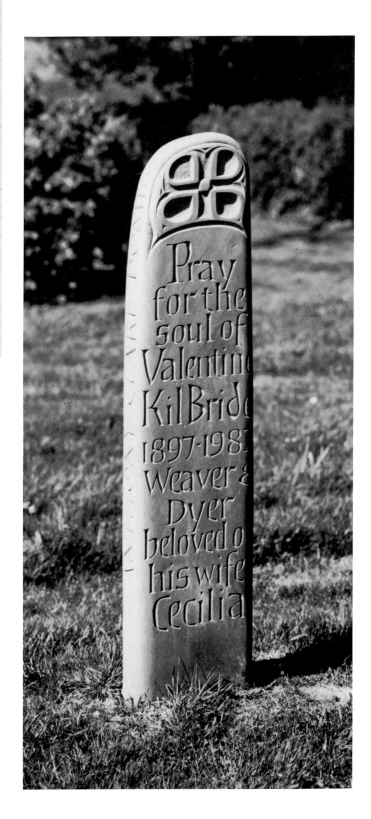

**John Skelton and Reuben
Walters**
Headstone. Ditchling burial
ground, Sussex. Red sandstone.
122 × 30.5 cm (48 × 12 in)

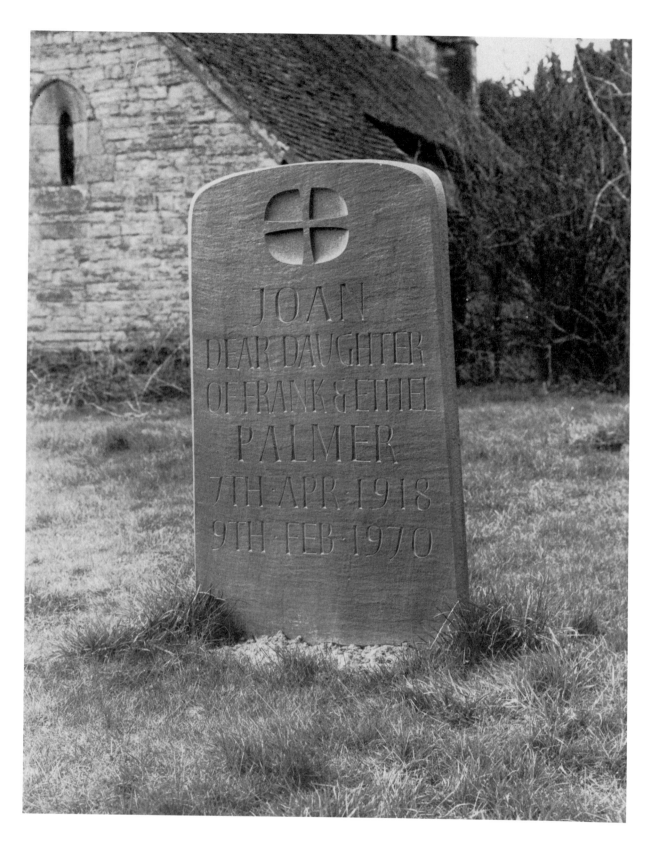

JOAN
DEAR DAUGHTER
OF FRANK & ETHEL
PALMER
7TH · APR · 1918
9TH · FEB · 1970

John Skelton and Jack Trowbridge
Designed by John Skelton and cut by Jack Trowbridge. Memorial in Thoroton Churchyard. Riven slate. 122 × 61 cm (48 × 24 in)

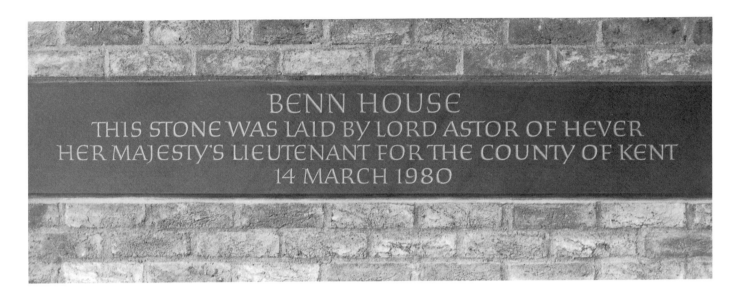

Tom Perkins

Foundation plaque for Benn
House. Lettering 'V' incised into
blue-black slate. 200 × 29 cm
(6 ft 6 in × 11½ in)

Welsh slate plaque for Wesley's
Chapel, London EC1. Letters 'V'
incised.

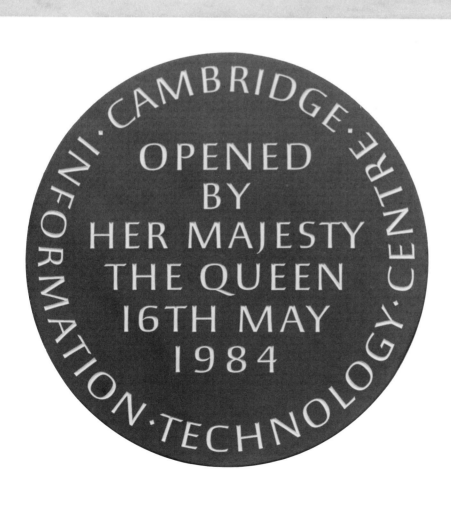

THE WOLFSON GALLERIES
OF CLASSICAL SCULPTURE
AND INSCRIPTIONS
OPENED BY THEIR ROYAL HIGHNESSES
THE PRINCE AND PRINCESS OF WALES
3 APRIL 1985

THESE GALLERIES HAVE BEEN CREATED
WITH THE HELP OF A GENEROUS GRANT
FROM THE WOLFSON FOUNDATION

CAMBRIDGE · INFORMATION · TECHNOLOGY · CENTRE ·

OPENED
BY
HER MAJESTY
THE QUEEN
16TH MAY
1984

John Skelton
Dedication tablet for the Gallery of
Classical Sculpture and Inscriptions
at the British Museum. Pentelic
marble. 114.4 × 71 cm (45 × 28 in)

Tom Perkins
Welsh slate plaque. Lettering 'V'
incised and painted off-white.
Commissioned by Cambridge
City Council. Diameter 51 cm
(20 in)

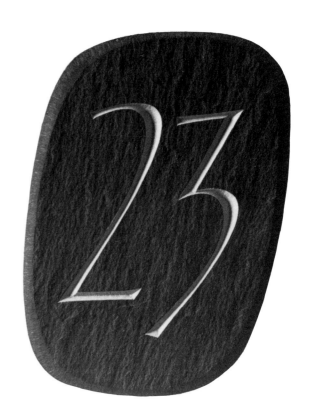

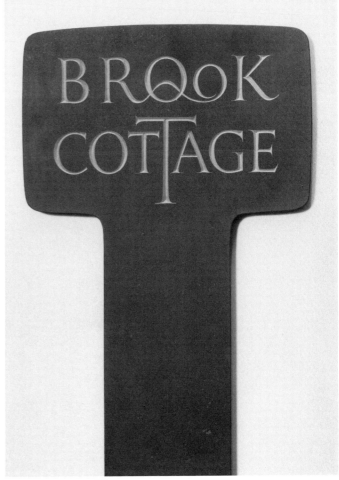

Richard Kindersley
Bronze numbers fixed to bronze
facia. Conduit Street, London.
Numbers 80 cm high × 25 cm
deep (32 × 9¾ in)

Tom Perkins
'23'. Riven Welsh slate. Numbers
'V' incised and painted off-white.
13 × 8 cm (5⅛ × 3⅛ in)

**David Kindersley and Lida
Lopes Cardozo**
Brook Cottage. Green slate. Letters
cut and painted. 67.3 cm (26½ in)

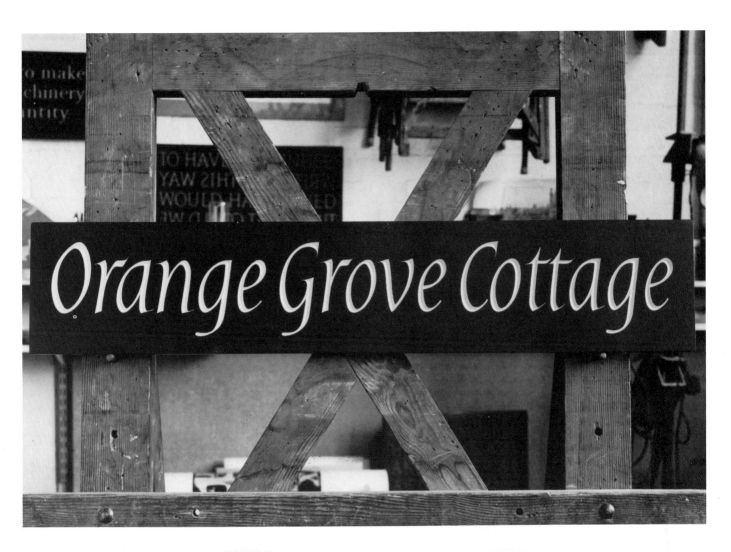

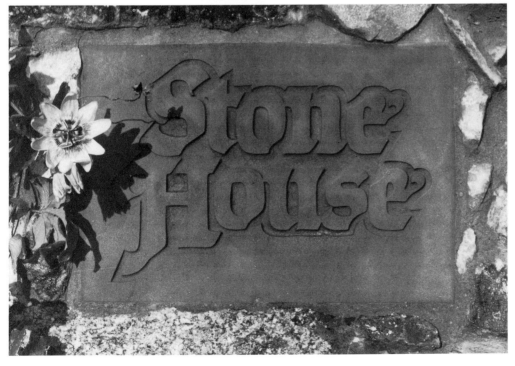

David Kindersley and Lida Lopes Cardozo
Orange Grove Cottage. Slate. Letters cut and painted.
17.8 × 76.2 cm (7 × 30 in)

David Harris
House name. Grit blasted in Chesterfield stone.
38.1 × 25.4 cm (15 × 10 in)

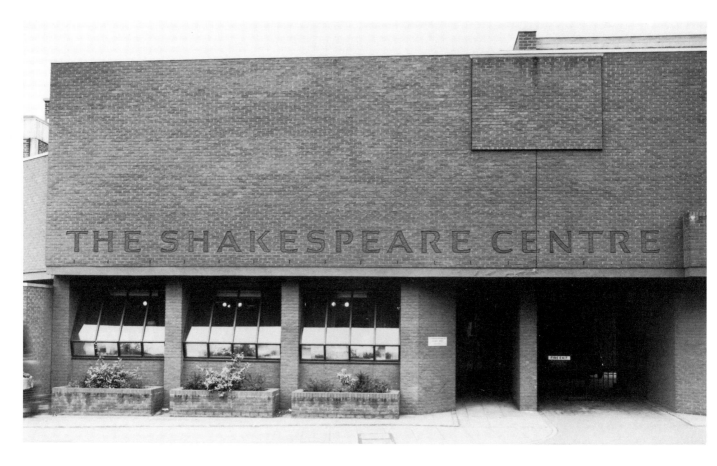

Richard Kindersley
The Shakespeare Centre. Carved
and dyed letters. Red brick with
dark brown dye. Letter height
50 cm (19¾ in)

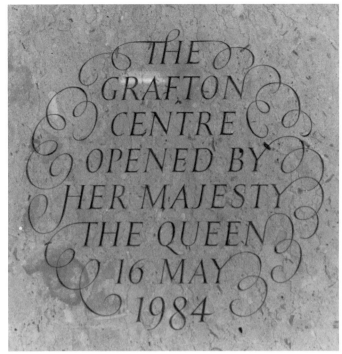

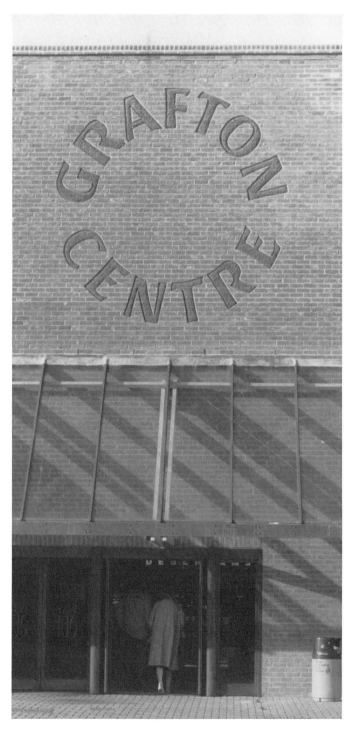

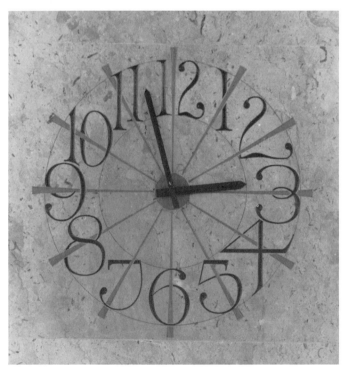

Richard Kindersley
The Grafton Centre, Cambridge.
Carved and dyed brick. Height of
letters 56 cm (22 in)

Carved and painted marble plaque
for the Grafton Centre, Cambridge.
Diameter 1.6 m (5 ft 3 in)

Marble clock face, carved and
painted directly onto the interior
wall of a new shopping centre in
Cambridge. Radial lines painted
ochre, numbers dark red. Diameter
1.5 m (60 in)

Richard Kindersley
Carved and painted Welsh slate.
40 cm (15¾ in) high

'This too shall pass away'. Cast
plaster letters. Originals in
expanded polystyrene. 1m
high × 17.5 m long (39⅜ in × 19 yd 2 ft)

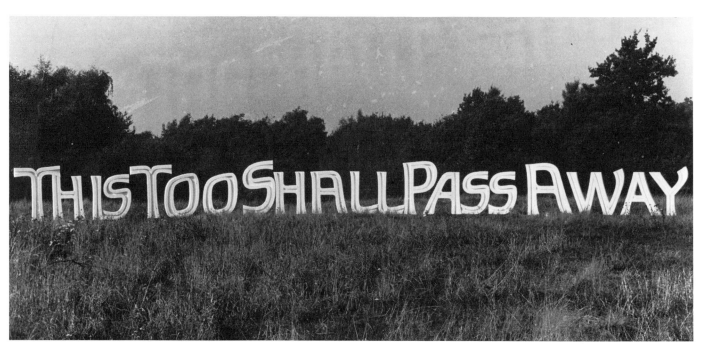

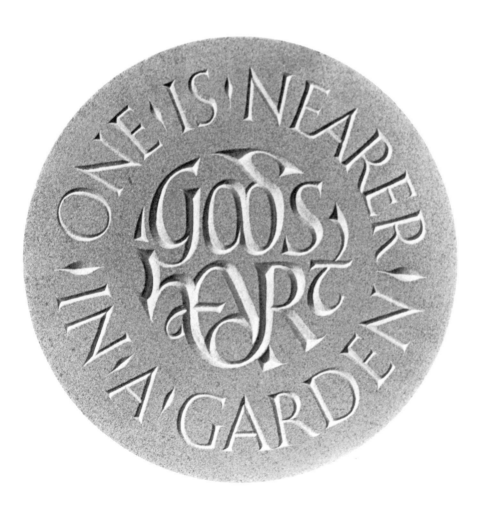

Jon Gibbs
Dark green with off-white letters.
Gilded and on a grey-greeen
mottled ground. 40 × 23 cm
(15¾ × 9 in)

John Shaw
'Garden text'. York stone with
incised lettering. Diameter 30.5 cm
(12 in)

Jon Gibbs
Dark green with off-white letters on a mottled ground. Diameter 60 cm (23⅝ in)

Sarah More
Foundation stone in riven Welsh slate. 76.2 × 33 cm (30 × 13 in)

BRANDRAMS HOUSING COOPERATIVE FOUNDATION STONE LAID BY CHRIS SMITH M·P AND HIS WORSHIP THE MAYOR OF SOUTHWARK COUNCILLOR PAT SULLIVAN 20 SEPTEMBER 1985

THIS HOUSE WAS BUILT FOR
ROBERT & ELIZABETH HIRSCH
IN OCTOBER MCMLXXV BY
VICTOR & DEREK MEEKS
MASTER BUILDERS OF LINTON
IN CAMBRIDGESHIRE

David Kindersley and Lida Lopes Cardozo
Hirsch. Slate. Letters cut and painted off-white. 36.8 × 47 cm (14$\frac{1}{2}$ × 18$\frac{1}{2}$ in)

Tom Perkins
'God giver of Life'. Bath stone.
Letters 'V' incised. Courtesy of
Jane Borchers. 30 × 30 cm
(11¾ × 11¾ in)

Teresa Elwes
A prayer from the orthodox
liturgy in French. 'V' incised
outline letters in Welsh slate.
27.9 × 63.5 cm (11 × 25 in)

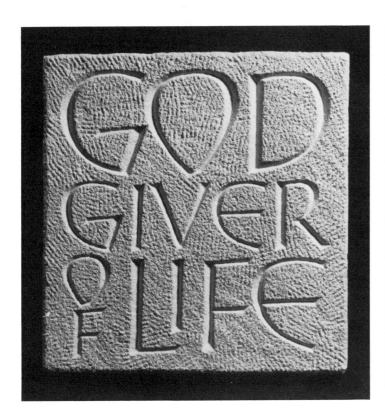

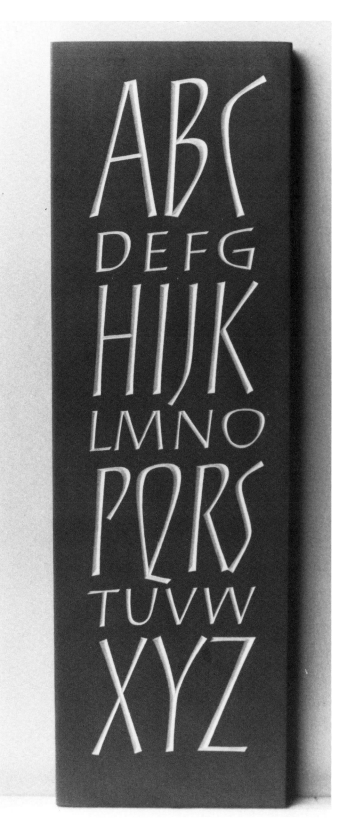

Tom Perkins
Alphabet. Welsh slate. Letters 'V'
incised and painted off-white.
48 × 15 cm (18⅞ × 5⅞ in)

Tom Perkins
Alphabet. Welsh slate. Letters 'V'
incised and painted off-white.
Commissioned by Eastern Arts.
43 × 13 cm (17 × 5⅛ in)

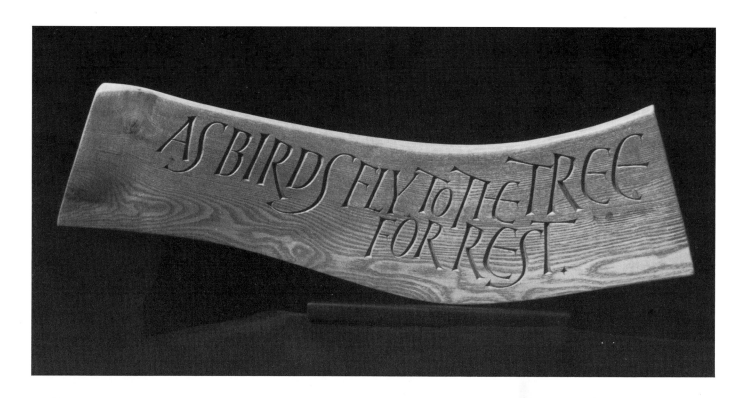

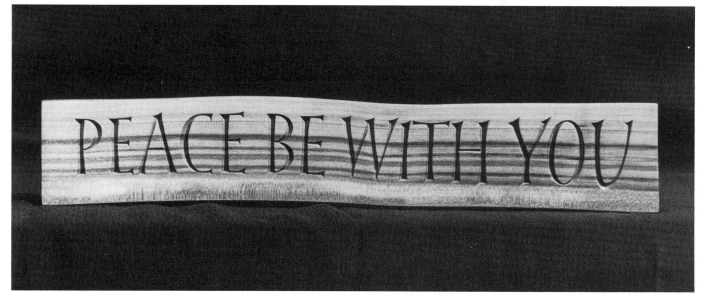

Martin Wenham

'Toccata 22'. Text from *The Ten Principal Upanishads* translated by Shree Purohit Swami and W B Yeats. Reproduced by permission of Faber and Faber. The complete text reads 'My son! All things fly to the self, as birds fly to the tree for rest.' English ash branch-wood, cleft and shaped. 68 cm (26¾ in) long

'Toccata 14'. Text from the *Book of Common Prayer*. English cherry wood, cleft and shaped. 40 cm (15¾ in) long

Martin Wenham
'Toccata 16'. Text from the
Oxyrhynchus Papyri 'Sayings of
our Lord'. The complete text reads
'Raise the stone and you shall find
me; cleave the wood and there am
I.' English oak, cleft and shaped.
Base of Welsh slate. 75 cm (29½ in)
high

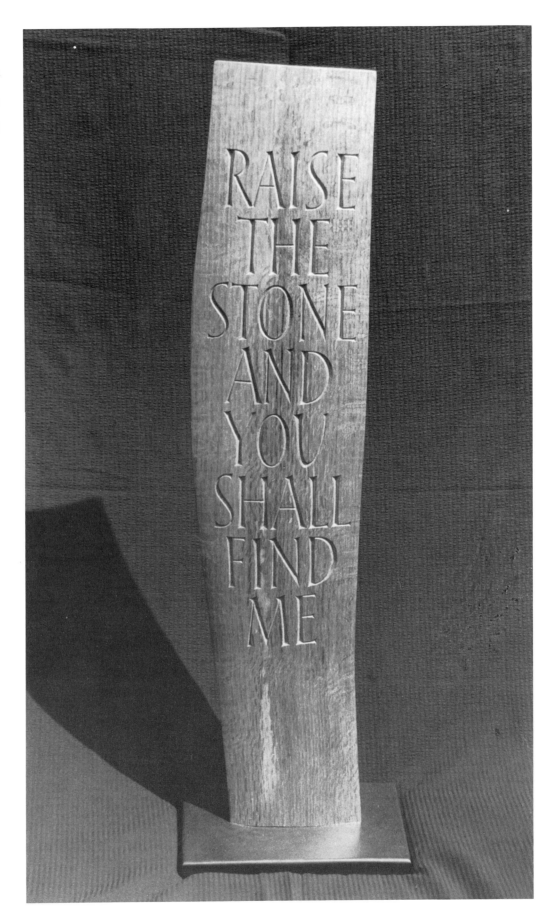

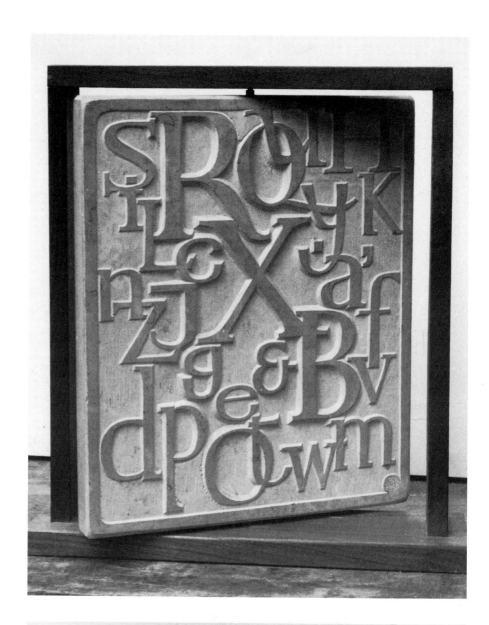

Helen Mary Skelton
Apprentice piece.
50.8 × 52.1 × 10.2 cm
(24 × 20½ × 4 in)

Michael Harvey
Stencil alphabet on wood. Painted
in acrylic paint in red, yellow,
black and blue on sawn wood.
63.5 × 33.9 cm (25 × 13¼ in)

152

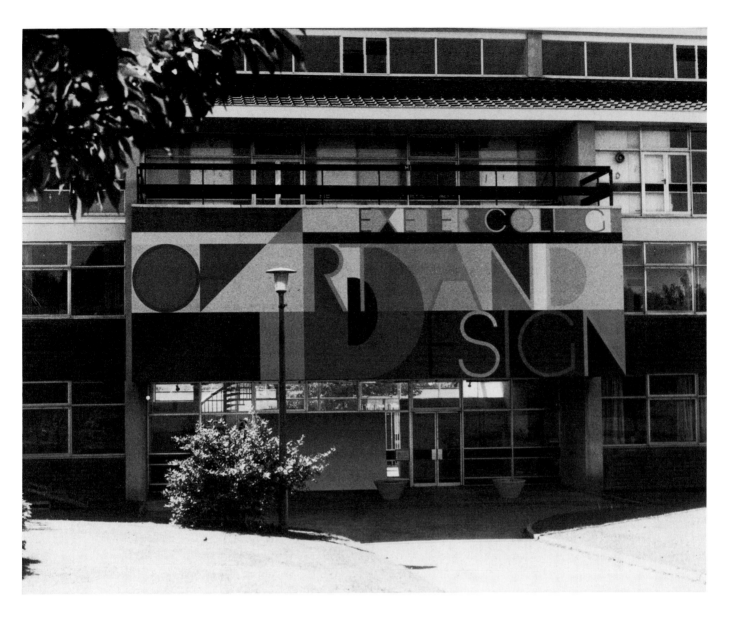

David Harris
Mural painted in exterior
emulsion. Exeter College of Art
and Design. 1070 × 35.6 cm
(42 × 14 in)

153

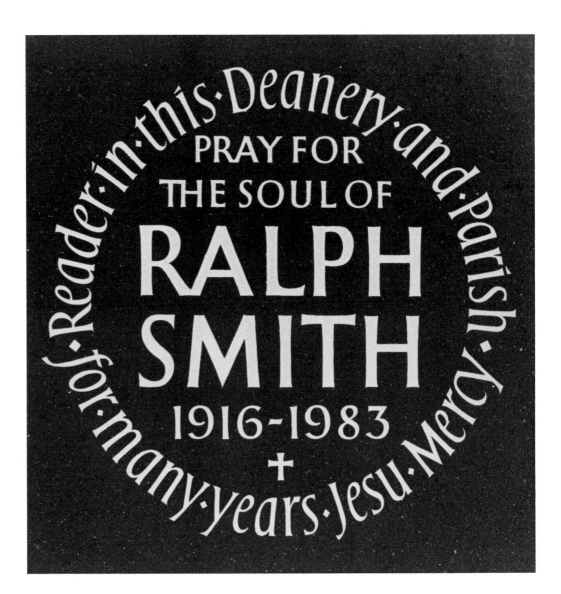

John Shaw
'Ralph Smith'. Floor tablet at
Chesterfield Parish Church,
Derbyshire. Lettering incised and
filled. 61 × 61 cm (24 × 24 in)

Annet Stirling
Oak alphabet, background cut
away. 61 × 25.4 cm (24 × 10 in)

St. Clair Richard
'Beware of the Dog'. Sign painted
on plexiglass. 20.3 × 71.1 cm
(8 × 28 in)

Michael Renton
Hanging sign for a bookshop. Gold
on dark green. 91.4 × 62.4 cm
(36 × 24 in)

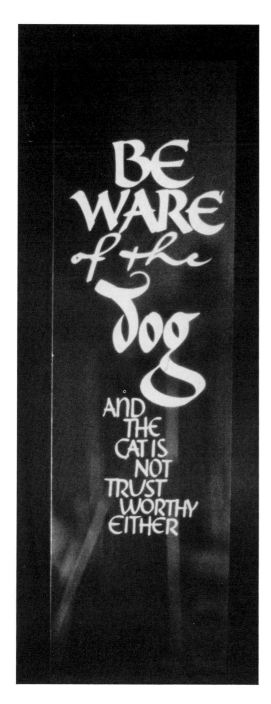

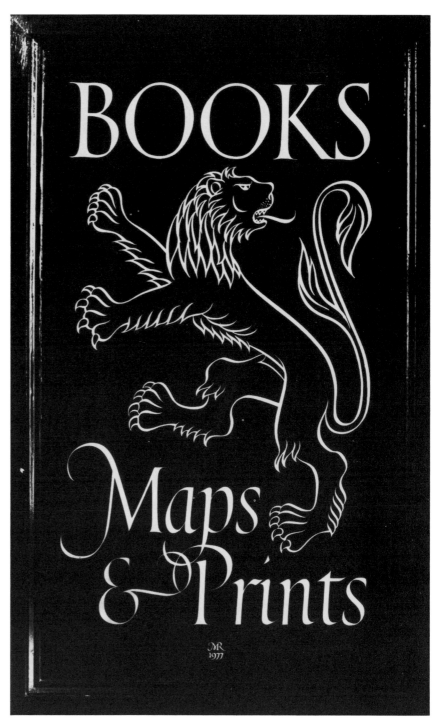

Sidney Day
'The Lord's Prayer'. Gold transfer
on a glass cylinder. 25.5 cm (10 in)
tall, 10 cm (4 in) in diameter

Bryant Fedden
Monogram on a goblet. Flexible
drive engraving.

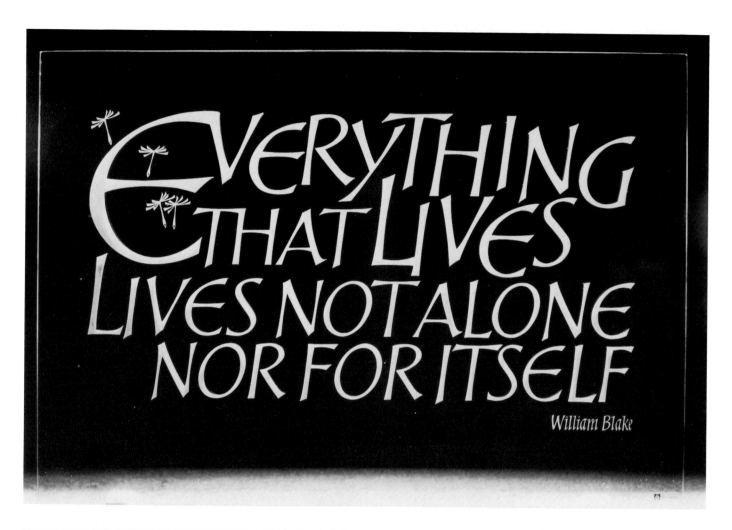

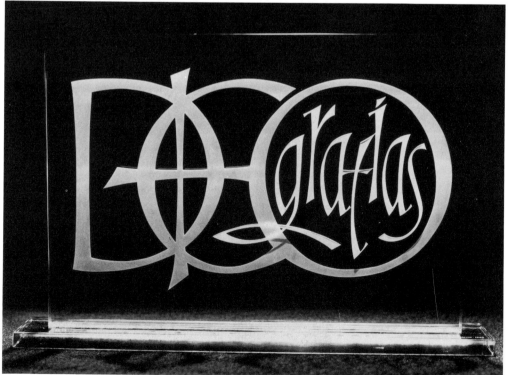

Pat Chaloner
'Everything that lives . . .'.
Quotation from William Blake.
Plate glass sandblasted. 67 × 45 cm
(26⅜ × 17¾ in)

'Deo gratias'. 10 mm (4 in) plate
glass sandblasted. 26 × 19 cm
(10¼ × 7½ in)

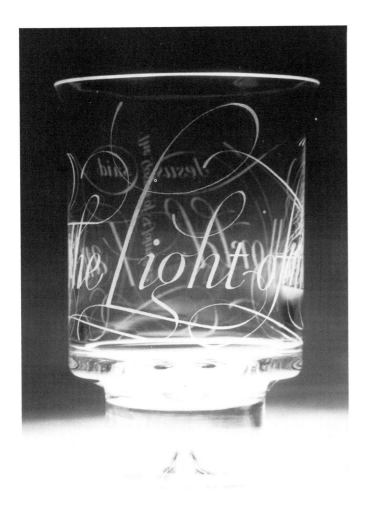

Audrie Leckie
'I am the light of the world'.
Engrave Dartington crystal
candleholder. 14 cm ($5\frac{1}{2}$ in) high

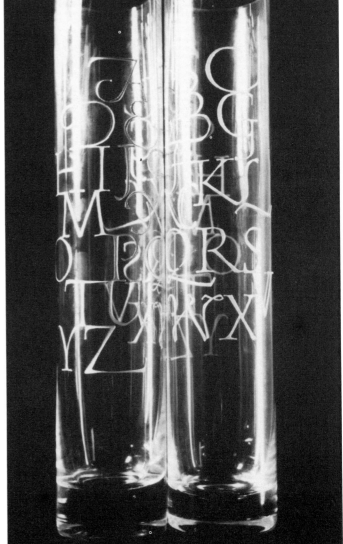

Gunnlaugur SE Briem
Sandblasting in glass. Swash
capitals, one set gilt. Lettering
originally designed for Hodder and
Stoughton.

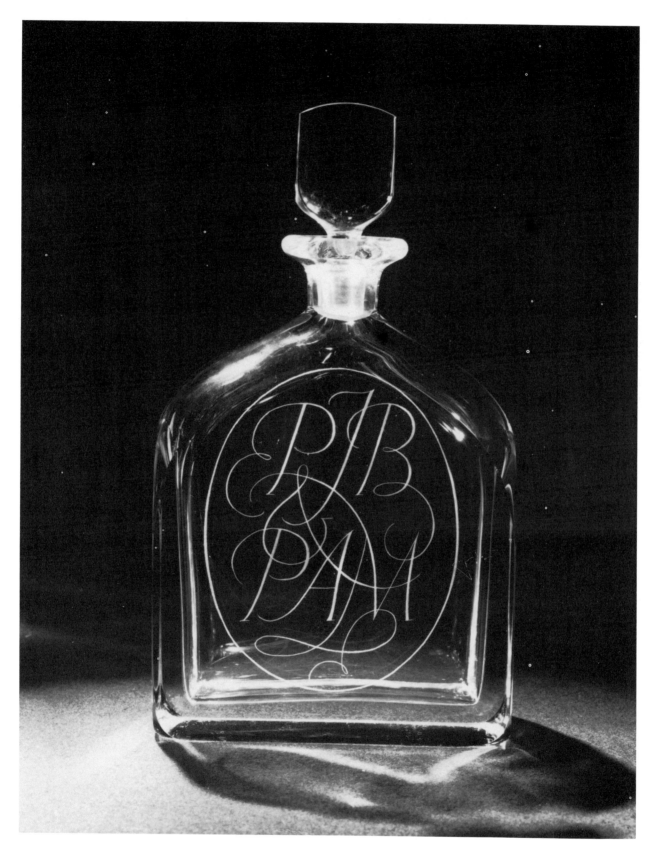

David Peace
A monogram of 'PJB' and 'PAM'.
Engraved on a decanter. For Mr
and Mrs Peter Buchanan.

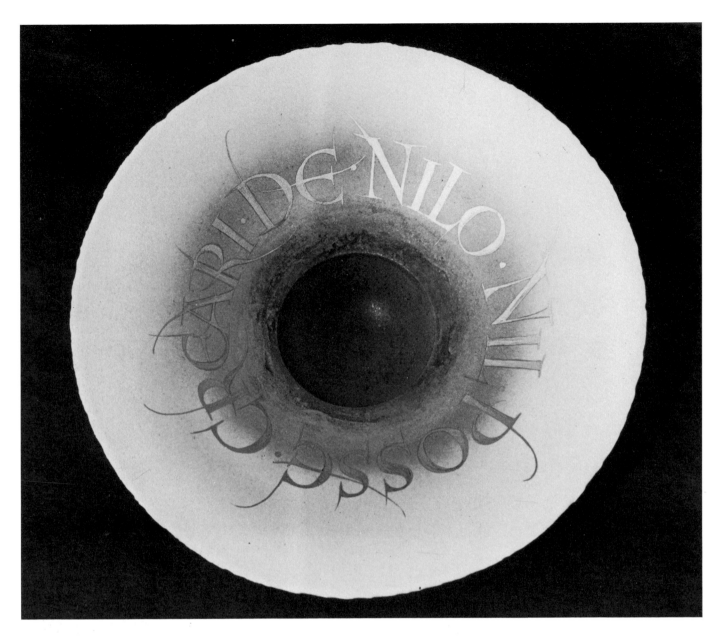

Mary White
Dish. Ivory white shaded through
pinky grey to dark green gold
lustre letters. Porcelain. Diameter
25 cm (9¾ in)

Donald Jackson
Logo of the Calligraphy
Connection international assembly
of lettering artists. Silver pendant.
3.2 cm (1¼ in) across

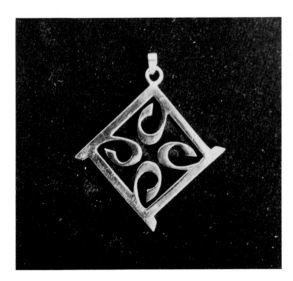

Tom Perkins
Painted inscription on Chinese silk,
commissioned by the Crafts
Council. 228 × 55 cm
(7 ft 6 in × 21¾ in)

Pat Russell
Jewish Prayer Shawl with Hebrew
lettering. Reverse applique in gold
lame and white wool crepe.

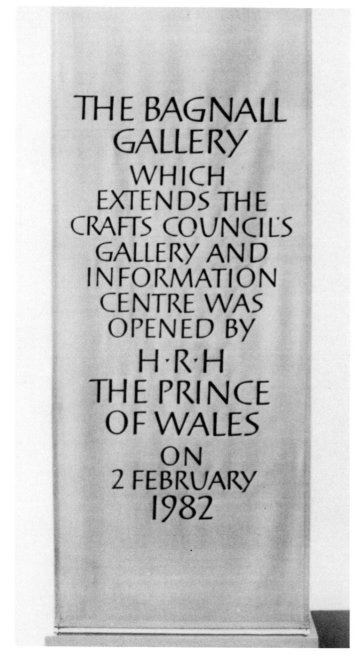

THE BAGNALL
GALLERY
WHICH
EXTENDS THE
CRAFTS COUNCIL'S
GALLERY AND
INFORMATION
CENTRE WAS
OPENED BY
H·R·H
THE PRINCE
OF WALES
ON
2 FEBRUARY
1982

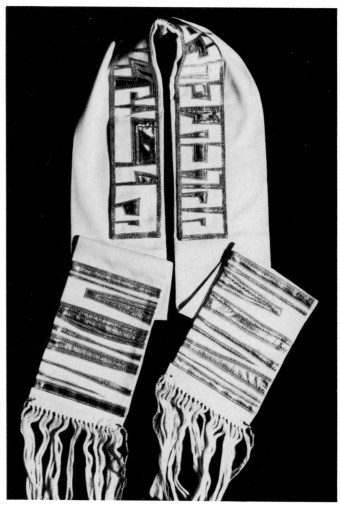

Right

Pat Russell

'Home Sweet Home'. Cut net and
machine embroidery on even
weave linen. 59 × 41 cm
(23½ × 16⅛ in)

Pat Russell

'The proper study of mankind is
woman'. Letters cut out in layers
of net and mounted on Japanese
paper. 102 × 70 cm (40½ × 27½ in)

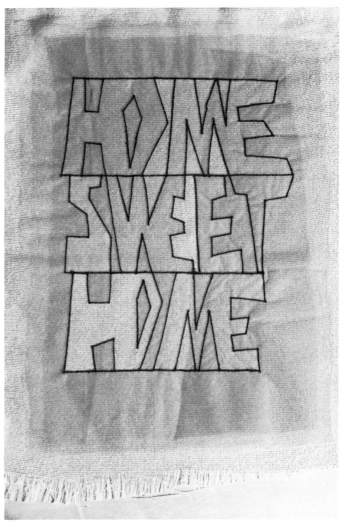

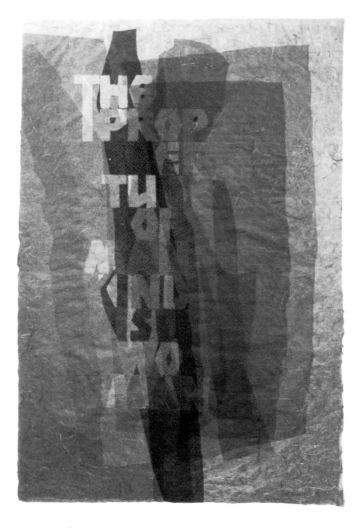

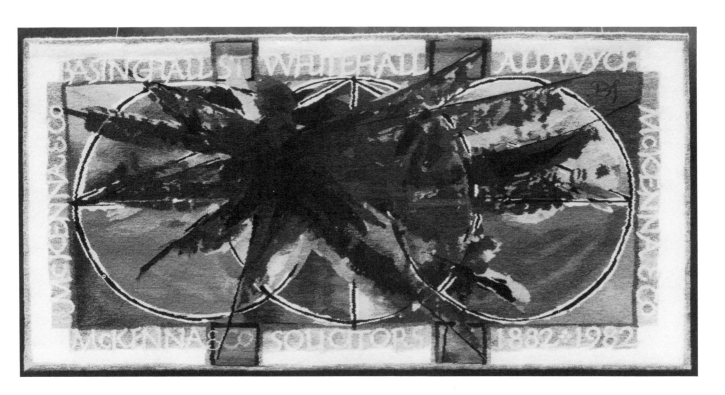

Donald Jackson
Tapestry representing justice across
the world. To commemorate the
centenary of McKenna & Co.
Woven by Valerie Power at the
West Dean Workshop in rich
colours. Photographed by
R. and P. Ellis. 100 × 200 cm
(39$\frac{3}{8}$ × 78$\frac{3}{4}$ in (Original
25.4 × 12.7 cm (10 × 5 in))

Index of calligraphers

Page numbers are given in brackets

Adrian Frutiger (73)
23 Villa Moderne, 94110 Arcueil, France

David Gatti (86, 87, 91)
40 View Acre Drive, Huntingdon, NY 11743, USA

Jon Gibbs (145, 146)
18 Oaktree Close, Ivybridge, Devon PL21 9RJ, UK

Guy Giunta (27,95,116)
7224 Walnut Street, Kansas City, MO 64114, USA

Gaynor Goffe (98, 115)
40 High Street, Sutton, Ely, Cambridge CB6 2RB, UK

Jenny Groat (75)
PO Box 295, Lagunitas, CA94938, USA

Peter Halliday (13, 52, 77, 98)
26 Stapenhill Road, Burton on Trent, Staffordshire, UK

David Harris (141, 153)
Stonehouse, 10 The Strand, Topsham, Exeter, Devon, UK

Michael Harvey (23, 152)
4 Valley Road, Bridport, Dorset, UK

Ann Hechle (12, 32–33)
The Old School, Buckland, Dinham, Somerset BA11 2QR, UK

Karlgeorg Hoeffer (118)
Weilburger 7, D-6050 Offenbach am Main, West Germany

Lorenzo Homar (14, 115)
Calle Estado 656, Miramar, PR 00907, USA

Kevin Horvath (66, 94, 101)
9127 Darnell, Lenexa, KS 66215, USA

Peter Horridge (78, 89, 90)
15a Berkeley Place, London SW19, UK

David Howells (13, 68, 69)
14 Mill Hill Drive, Shoreham by Sea, West Sussex, BN43 5PL, UK

Nancy Ouchida-Howells (69)
14 Mill Hill Drive, Shoreham by Sea, West Sussex, BN43 5PL, UK

Vera Ibbett (54)
89 Chipstead Lane, Lower Kingswood, Surrey, UK

Tom Ingmire (45, 46, 47)
845 Lombard, San Francisco, CA 94133, USA

Donald Jackson (10, 19, 21, 74, 85, 93, 96, 99, 108, 160, 163)
The Calligraphy Centre, The Hendre, Monmouth NP5 4HQ, UK

Ken Jackson (103, 112)
660 San Fernando Road, Appt 7, Los Angeles, CA 90065, USA

Martin Jackson (63)
2065 Creelman Avenue, Vancouver, BC V6J 1C2, Canada

Jeff Jeffreys (67)
509 Genard Street, Austin, Texas 78751, USA

Jerry Kelly (88)
81–16 167th Street, Jamaica, NY 11432, USA

David Kindersley (134, 135, 140, 141, 147)
152 Victoria Road, Cambridge, UK

Richard Kindersley (140, 142, 143, 144)
40 Cardigan Street, London SE11 5PF, UK

Stan Knight (11, 43, 44)
1580 Highway 9, Mount Vernon, Washington State,
WA 98273, USA

Lubomír Krátky (72, 122, 123)
Detvianská 6, Bratislava 83106, Czechoslovakia

Pattie Lamb (105, 111)
c/o 54 Boileau Road, London SW13 9BL, UK

Jean Larcher (15)
16 Chemin des Bourgognes, 95000 Cergy, France

Thomas Laudy (58)
PO Box 10118, 1301 AC Almere, Netherlands

Lars Olof Laurentii (116)
Kungsgaten 30, 111 35 Stockholm, Sweden

Audrey Leckie (158)
33 Halford Road, Richmond, Surrey TW10 6AW, UK

Lilly Lee (24, 89)
26 Newton Avenue, London W3 8AL, UK

Alfred Linz (20, 23, 26, 28) – deceased
Christian-Wildner Str 15, 85 Nurnberg, West Germany

Lida Lopes-Cardozo (134, 135, 140, 141, 147)
152 Victoria Road, Cambridge, UK

Dorothy Mahoney (10) – deceased
c/o SSI, 54 Boileau Road, London SW13, UK

Mike Manoogian (102, 104)
7457 Beck Avenue, North Hollywood, CA 91605, USA

Paul Maurer (74)
Rdl Box 11, Centre Hall, PA 16828, USA

Claude Mediavilla (85)
2 rue du Colombier, 94200 Ivry, France

David Mekelburg (13, 37, 113, 118)
421 South Van Ness Avenue, #48, Los Angeles, CA 90020, USA

José Mendoza y Almeida (84)
23 rue des Pommerets, 92310 Sevres, France

Sarah More (146)
50 Elmdale Road, Bedminster, Bristol BS3 3JE, UK

Brody Neuenschwander (26, 42)
Cwm, Welsh Newton, Monmouth NP5 3RW, UK

Peter Noth (72, 88)
4945 Central Street, Kansas City, MO 64112, USA

John Nash (56)
32 Riversdale Road, London N5, UK

Tom Nikosey (102, 114)
7417 Melrose Avenue, Los Angeles, CA 90046, USA

Christine Oxley (48)
Rosedale Lodge, Pudleston, Leominster, Herefordshire, UK

Derek Pao (18)
18 B3 San Francisco Tower, 35 Ventris Road, Happy Valley,
Hong Kong

David Peace (159)
Abbots End, Hemingford Abbots, Huntingdon PE18 9AA, UK

Charles Pearce (30, 31)
360 Van Duzer Street, Stapleton, Staten Island, NY 10304, USA

Tom Perkins (138,139, 140, 148, 149, 161)
40 High Street, Sutton, Ely, Cambridge CB6 2RB, UK

Joan Pilsbury (39)
Sycamore Farm, Alphamstone, Bures, Suffolk, UK

Margaret Prasthofer (22, 23, 24)
102 Montgomery Avenue, Ardmore, PA 19003, USA

John Prestiani (82, 83)
2005 Channing Way, Berkeley, CA 94704, USA

Leonid Proneko (50)
350065 Krasnodar, Nevkipelova Str 15–67, USSR

David Quay (104, 105)
Studio 12, 10–12 Archer Street, London WIV 7HG, UK

Stephen Raw (87)
1 Hartington Road, Chorlton cum Hardy, Manchester, UK

Ieuan Rees (97, 132, 133)
Cwmllwchwr Mill, Llandybie, Ammanford, Dyfed, S. Wales, UK

Michael Renton (155)
Brook Granary, Icklesham, Winchelsea, East Sussex, UK

St Clair Richard (155)
360 Van Duzer Street, Stapleford, Staten Island, NY 10304, USA

Marcy Robinson (34, 35)
1G Building 3, 181 River Road, Nutley, NJ 07110, USA

Pat Russell (41, 161, 162)
48 East St Helen's Street, Abingdon, Oxford, UK

John Shaw (145, 154)
26 Bridge Street, Alnwick, Northumberland NE66 1QY, UK

Paul Shaw (14, 107, 119)
785 West End Avenue, #16A, New York City, NY 10025, USA

Werner Schneider (60, 84)
Am Langen Land 2, 5929 Laasphe, West Germany

John Skelton (134, 136, 137, 139)
Blabers Mead, Hassocks, Sussex, UK

Mary Helen Skelton (152)
Rose Acre, Malthouse Lane, Hurstpierpoint, W. Sussex

John Smith (17)
Tannenbaum, 130 Gayton Road, Kings Lynn, Norfolk, UK

Kennedy Smith (49)
Lindisfarne, Netherhampton, Salisbury, Wiltshire, UK

Sam Somerville (9, 96)
14 Cambourne Road, Morden, Surrey, UK

Bonnie Spiegel (15, 54, 94)
121 William Street, Portland, ME 04103, USA

John Stevens (48, 59, 62, 86, 110)
68 Rita Drive, East Meadow, NY 11554, USA

Annet Stirling (154)
3 The Drive, Amersham, Buckinghamshire, UK

Susie Taylor (61, 116)
1256 19th Avenue, San Francisco, CA 94122, USA

Villu Toots (119, 120, 121)
A Kapi 6–10, 200 031 Tallinn, Estonia, USSR

Jack Trowbridge (134, 137)
75 Royal George Road, Burgess Hill, Sussex RH15 9SG, UK

Alison Urwick (40)
Crossways, Bloxham, Banbury, Oxon, UK

Mark Van Stone (12, 55)
3422 SE Grant Court, Portland, OR 97214, USA

Jovica Veljović (28, 29, 91)
Kraljice Katarine 57, 11000 Belgrade, Yugoslavia

Reuben Walters (136)
c/o John Skelton

Julian Waters (76)
9509 Aspenwood Place, Gaithersburg, MD 20879, USA

Sheila Waters (38)
20740 Warfield Court, Gaithersburg, MD 20879, USA

Pat Weisberg (79)
328 Central Park West, New York, NY 10025, USA

Martin Wenham (150, 151)
68a Greenhill Road, Coalville, Leicestershire LE6 3RH, UK

Wendy Westover (35)
55 Hazlewell Road, London SW15, UK

Mary White (160)
Zimmerplatzweg 6, 6551 Wonsheim, West Germany

Martin Wilke (58, 91)
Hildegardstrasse 4, 1000 Berlin 31, West Germany

Robert Williams (43, 93, 118)
5703 South Blackstone Avenue, Chicago, IL 60637, USA

David Wood (11)
7-102 Bay Road, Waverton, NSW 2060, Australia

John Woodcock (15, 34, 62, 78, 84, 86, 93, 108)
1 Stanley's Cottages, Dene Street, Dorking, Surrey RH4 2DW, UK

Hermann Zapf (11)
Seitersweg 35, 61000 Darmstadt, West Germany

Acknowledgements

The publishers wish to thank the Society of Scribes
and Illuminators, and in particular Sue Cavendish, for
all their hard work and enthusiasm in putting this
book together, and also all the scribes and lettering
artists who contributed work for selection for the book.

Whilst every effort has been made to secure
permissions to reproduce work and to correctly credit
sources, this has in some cases proved to be impossible.
We would therefore like to apologise for any
omissions in this respect.